D1439180

The Observer's Pocket Series

VICTORIANA

About the book

As time distances us from our Victorian forbears we are becoming increasingly fascinated by the way they lived, what they wore and how they decorated their homes. The art objects and items of everyday use that make up Victoriana are still not too difficult to find, even if the days when treasures could be picked up for a song are gone for ever. Articles once rejected as ugly or useless are still found in attics, and antique shops and market stalls still yield attractive items at reasonable prices.

The first part of this book is designed to give a general picture of the state of the arts and crafts of Victorian England; the second part describes some of the 'collectables' that might appeal to the aspiring collector: beadwork, fairings, fans, music covers, pincushions, Staffordshire figures, Valentine cards, and many more.

The book is entertainingly written and full of essential information, and the photographs vividly enhance the descriptions of the riches of Victoriana. As well as giving a broad view of the architecture, painting and major crafts of the period, it will prove a practical guide to small decorative antiques for the collector with a limited purse but unlimited enthusiasm.

About the authors

Geoffrey Palmer was the headmaster of a primary school in London for many years, and Noel Lloyd has been an actor on stage, radio and television. Together they have written over twenty-five books, with subjects ranging from travel, music, archaeology and folklore to stories of ghosts and witches and anthologies of poems for children. They now run a secondhand bookshop in Eye, Suffolk. What spare time they have is spent in travelling, listening to music and browsing in antique shops, museums and art galleries.

The Observer's Book of

VICTORIANA

Geoffrey Palmer and Noel Lloyd

WITH 13 COLOUR AND 87 BLACK AND WHITE
PHOTOGRAPHS

BLOOMSBURY BOOKS
LONDON

PENGUIN BOOKS

Published by the Penguin Group
Penguin Books Ltd, 27 Wrights Lane, London W8 5TZ, England
Penguin Books USA Inc., 375 Hudson Street, New York, New York 10014, USA
Penguin Books Australia Ltd, Ringwood, Victoria, Australia
Penguin Books Canada Ltd, 10 Alcorn Avenue, Toronto, Ontario, Canada M4V 3E
Penguin Books (NZ) Ltd, 182-190 Wairau Road, Auckland 10, New Zealand

Penguin Books Ltd, Registered Offices: Harmondsworth, Middlesex, England

First published by Frederick Warne & Co Ltd

This edition published by Bloomsbury Books, an imprint of
Godfrey Cave Associates, 42 Bloomsbury Street, London, WC1B 3QJ,
under licence from Penguin Books Limited, 1992

1 3 5 7 9 10 8 6 4 2

Copyright © 1976 Frederick Warne & Co Ltd

Printed and bound in Great Britain by
BPCC Hazells Ltd
Member of BPCC Ltd

ISBN 1-8547-1029-X

CONTENTS

ACKNOWLEDGEMENTS

The authors and publisher are grateful to the following for
permission to reproduce black and white photographs in this book:
Philip de Bay, pages 160, 164; City Art Gallery, Manchester, pages
49 (above), 49 (below), 50; City of Birmingham Museum and Art
Gallery, page 51; City Museum, Stoke on Trent, pages 99, 105
(below), 107, 124, 136 (above), 173; Dyson Perrins Museum, page
109; Harris Museum and Art Gallery, page 129; A. F. Kersting,
pages 30, 32, 39 (above), 39 (below); Leeds City Council, page 26;
Noel Lloyd, pages 105 (above), 106, 111, 112, 139, 144, 169 (left),
167 (right); Minton Museum, Royal Doulton Tableware, pages
100 (left), 100 (right); National Monuments Record, pages 29, 34,
40; Pilkington Brothers Ltd, page 76 (below); Russell Coates Art
Gallery, pages 44, 46; Tunbridge Wells Museum, pages 176, 177;
Tyne and Wear County Council Museums Service, pages 135, 159;
Crown Copyright Victoria and Albert Museum, pages 14, 18, 20, 21,
23, 59, 60, 62, 76 (above), 77, 79, 83, 84 (below), 86, 87, 89, 91, 92,
94, 95, 104, 114, 118, 120, 122, 125, 127, 131, 136 (below), 140
(above), 140 (below), 142, 147 (above), 147 (below), 154, 170, 178,
182; Wedgwood Museum, pages 108 (above), 109, 113; William
Morris Gallery, pages 70, 115; The Worshipful Company of
Goldsmiths, page 84 (above).

The authors and publisher are also grateful to the following for
permission to reproduce photographs in the colour section of the
book: Philip de Bay and the Victoria and Albert Museum
(stevengraph, cameo brooch, barge ware teapot); Birmingham
Museum and Art Gallery (*The Long Engagement*); The Geffrye
Museum (mid-Victorian parlour); Noel Lloyd (Toby jug, tureen,
pastille-burner); Pilkington Glass Museum (cameo vase); The Royal
Borough of Kensington and Chelsea (William de Morgan tiles); The
Wedgwood Museum (Queen's ware jardinière).

The authors would also like to thank George and Daphne
Toynbee-Clarke and F. H. Baddeley for their permission to
photograph items from their collections.

PREFACE

The purpose of this book is twofold. First, in order to help the reader to understand the distinctive flavour of Victorian antiques and the kind of society that produced them, we aim to give as full a picture as possible of the state of the arts and crafts of Victorian England; and to record the changes that took place in every aspect of artistic life, as distinct from the changes in industry, science and social conditions that were happening at the same time. It is a vast field to cover and in a book of this size it is impossible to do more than give a general account of the styles and fashions in architecture, painting and the major crafts. There are, of course, innumerable books of specialist interest that will fill in the gaps and paint the picture of nineteenth-century culture in deeper colours (see the Select Bibliography on page 183).

The second purpose of this book is to describe some of the period's 'collectables' that might appeal to the aspiring collector of Victoriana. Again, it would not have been possible to cover every aspect of small antiques, so we have concentrated on those which offer the greatest opportunities to the enthusiast. As time distances us more and more from our Victorian great-grandparents, we are experiencing an increasing affection for the way they lived, what they wore and how they built and decorated their homes. The collecting of objects surviving from the Victorian age has become something of a cult. It may spring from a nostalgia for

the past which has attained a golden glow and acts as a means of escape from the problems of the present, but the passion for things Victorian shows no sign of growing less.

Antiques of periods before the nineteenth century are becoming more and more scarce and cost much more than the ordinary person can afford. Although, strictly speaking, an authentic antique is at least a hundred years old, and complicates things by cutting across the Victorian period, the art objects and items of everyday use that make up Victoriana are still not difficult to find and many are within the means of the beginning collector. They are, too, a form of investment and are likely to increase in value over the years.

It should not be forgotten that the period had no real style of its own but drew its decorative elements from almost every other period and place. There was much that was ugly and ostentatious about Victorian arts and crafts. The Great Exhibition of 1851 had its full complement of things in atrocious taste, but often the vulgar and mediocre have been taken as the norm and many of the products of Victorian craftsmen tend to be overlooked. Attractive and exquisitely made articles can be found as easily as those which draw a gasp of horror.

With prices for original items rising, it is inevitable that fakes and reproductions should be on the increase, but copies of ornaments, jewellery, etc., will not deceive any but the most unwary. It is when they age and become more like what they are pretending to be that caution in buying is essential. There is nothing wrong in buying a reproduction, of course, if it appeals to one's aesthetic sense, but it should not be included in a collection of Victoriana!

Britain is still rich in Victorian decorative objects,

fortunately, even though the demand is increasing. Reminders of the past are all around us, from public buildings, monuments, bridges and streets of houses to the small items seen in antique shops and street markets; and articles once rejected as ugly or useless are still being found in family attics and storerooms. It is not likely that a search will reveal fine porcelain or silver or a Landseer painting, but it will be surprising if lesser but still interesting items do not turn up: a pincushion, perhaps, a piece of jet jewellery, a box with mother-of-pearl inlay or a scrapbook of Valentines or Christmas cards. There is sure to be something which can be made the basis of a collection and, when once a start has been made, the field is wide open.

What the collector then has to develop is a keen eye and a sensitive 'nose'. He must be willing to study intensively and widely, to visit museums and private collections; he must be prepared to learn the hard way and profit by his mistakes; and he must become engrossed in the life of the times that produced the objects of his interest. We hope in this book that he may find the basic information to start him on an intriguing and enjoyable quest.

INTRODUCTION

The word 'Victorian' can at best be but a vague term. It is impossible to embrace the whole of England during the 63 years of Queen Victoria's reign by a single epithet. There was no single Victorian England because during that long period the social, intellectual and technological changes were so vast and far-reaching that every aspect of life was affected and continued to change up to the end of the nineteenth century.

Fundamentally, the record of the years chronicles the swing from agriculture to industry, from life in the country to life in towns, from the dominance of the aristocracy to the rise of the working classes, from the coarseness of Regency society to the respectability of the Victorians, and from artistic elegance and freedom to solidity and authority.

In 1837, when Victoria came to the throne, the Industrial Revolution had been under way for 70 or more years, and its effects were now evident in the booming of industrial prosperity and the rapid expansion of population (which rose from $18\frac{1}{2}$ million in 1841 to 37 million in 1901). Acts of Parliament began to favour the property-owning middle classes, with their growing spending power, at the expense of the landed gentry, whose monopoly of power and wealth was challenged for the first time; and until the agricultural depression of the 1870s England reached the peak of her dominance as an economic, industrial and imperial power. The emergence of America and Germany as

industrial competitors in the last third of the century saw the country's power decline in everything except the patches of red on the map.

During the Victorian era London lost its pre-eminence to a certain extent when cities such as Birmingham, Leeds, Liverpool and Halifax became great centres for the iron, cotton and wool industries. Social changes were encouraged by improvements in transport, especially the expansion of the railways, 5,000 miles of which had been built by 1848. Their cuttings, embankments, tunnels, bridges and viaducts necessitated engineering skill, ingenuity and organisation on a scale never before attempted, and perhaps never since surpassed. Travel became accessible to all, even eventually to the working classes. The aristocracy grew richer by the development of their lands for railways, mines and new towns. The middle classes acquired wealth through investments and by providing specialised services, and the standard of living of many of the workers improved, though the majority still earned only enough to provide themselves with the bare necessities of life and they had, as yet, no part of power or social importance. The really poor lived in filthy and overcrowded conditions in the slums of the industrial cities.

The general belief of both Whigs and Tories was that the individual should make his own way in life with as little interference in his affairs as possible. It was essential that the liberty of the governing classes should be undisturbed. The great division between the rich and the poor was thus inevitable, but it was recognised as an evil by the caring few—the social reformers, revolutionary theorists and some churchmen. Lord Shaftesbury and his fellow reformers thought that social evils could be ameliorated by working out improvements within the existing system, and Royal Commis-

sions and Select Committees made certain that private rights had to give way to public good. Factory legislation, health measures, state education and an increase in the powers of local government were all instrumental in lightening the lot of the lowly and depressed millions who worked in mill and mine, in field and factory. Marx and Engels advocated the overthrow of the capitalist system, and F. D. Maurice and Charles Kingsley had their own brands of Christian Socialism. But, though there were times when the subterranean rumblings of revolutionary fervour caused concern and fear among the middle and upper classes, the mass of the underfed and exploited never got as far as wishing to do away with the Queen and the constitution.

The essence of Victorian thinking was based on self-confidence, hope, and belief in the future, together with national pride in achievement and the certainty that no problem was insoluble. There was a deep sense of security. Without question Britain ruled the waves and the safety of the nation was in no way threatened. The prosperity of the middle classes meant that no danger of revolution, civil war or tyrannous autocracy—things that were happening in other parts of the world—came from that quarter. Trust in institutions, adaptation and reform without violence was the way to the good life for all. Individual behaviour and the ordering of society had to be rigidly controlled, and the repressive effect of these ideas bore down heavily on people who had the temerity to question or defy them. Moral standards were the expressed will of God. Obedience without question was a virtue, and the authoritarian idea (nearly always in favour of the male) permeated society from government to the family. The law met violence with brutality, and the prison system was harshly punitive.

As the years went on, however, and a new century came in sight, the whole basis of English life changed, and changed rapidly. The 63 years of Victoria's reign in fact covered two Englands, differing from as well as resembling each other. The 1870s may be regarded as the dividing line. It was a time when the hopes of the early reformers became the laws of the land, when democratic suffrage was established, when religious doubts were openly discussed and an assault on traditional Christianity was under way.

The materialism and corruption of society was attacked by Trollope, Thomas Hughes, Matthew Arnold, William Morris and others. A growing number of university colleges were founded, some to give opportunities for higher education for women; and technical colleges encouraged scientific studies. Bicycles, motor cars, the telephone, typewriter, the electric telegraph, the entrance of women into the professions, birth control, the rise of the popular press—all were fuel to the conflagration that was consuming the old values, the ordered society, the virtues of obedience, deference, resignation; and into the flames the artists, writers and craftsmen plunged their own faggots.

The Pre-Raphaelites, and Ruskin, Wilde and Whistler, were among those who scorned the moral purpose of art, mocked the sentimentality of earlier painters and sculptors, and derided the solid, sombre and over-elaborate. The Aesthetic Movement, the Arts and Crafts Movement, and Art Nouveau all played their part in changing taste and style, clearing away the burned-out ashes of the old and planting the ground with the seeds of their own revolutionary ideas.

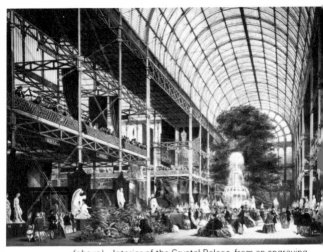

(above) Interior of the Crystal Palace, from an engraving
for the Great Exhibition catalogue
(below) View of the south side of the Crystal Palace, from
an engraving for the Great Exhibition catalogue

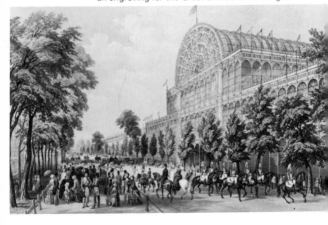

PART ONE

1 THE GREAT EXHIBITION

No other event gives us so full and fascinating a picture of the state of the art and craft scene in mid-nineteenth century as the Great Exhibition of 1851. It was the largest, most lavish and best attended display of accomplishments and projections into the future ever assembled up to that time, and was the first to bring all the nations of the world together in friendly competition. Its purpose was threefold: exhibition, competition and encouragement.

Without doubt its creator was Prince Albert, husband of Queen Victoria and later Prince Consort; though Henry Cole, an Assistant Keeper at the Record Office, is also credited with the idea, and he became the Prince's right-hand man in promoting the scheme. Prince Albert laid the idea before the Royal Society of Arts, of which he was President, in 1849. There had been exhibitions before, but of moderate size and national in character. This one, at which would be shown the raw materials and products, inventions, manufactures and arts of all the world, would, it was believed, convince the nations that in the lucrative arts of peace rather than in the destructive panoply of war lay their moral and material salvation.

The scheme came up against almost insuperable difficulties from the beginning, not the least of which was where it should be held. The Prince suggested a site in Hyde Park in preference to Somerset House, the first suggestion, and, as President of the Royal Commission,

the controlling body, he concerned himself with every administrative detail.

A shudder ran through Mayfair and Belgravia when Hyde Park was chosen; it was as if Dante's *Inferno* was to come to London. The Prince received many abusive letters and, because he was a German, he was called revolutionary, secret agent and traitor. It was not until the Exhibition had proved hugely successful that he gained the respect and popularity that he had not up to then enjoyed. His lasting memorial is the extraordinary structure now standing in London's Kensington Gardens in which he is depicted with the catalogue of the Exhibition in his hands.

Although the Great Exhibition aroused greater enthusiasm among ordinary people than any other show of its kind, the opposition was determined and very vocal. The forces of conservatism claimed that it was unwanted, unnecessary and a dangerous innovation. Extremists in the Church thought that the wrath of God would fall upon the organisers. There were fears of unruly crowds and of violence from Continental revolutionaries. The assassination of the Queen was gloomily foretold. Householders whose view over Hyde Park would be spoiled were also vociferous. 'Take care of your wives and daughters, your property and your lives,' thundered an MP in the House of Commons. Lord Brougham sponsored a petition to the House of Lords against the use of Hyde Park, and *The Times* reported that foreigners were hiring nearby houses to be used as brothels. *Punch*, often rude to Albert, was heavily sarcastic on the subject, but eventually relented and changed its attitude to one of grudging approval.

Fortunately, the opponents were outnumbered by supporters. The Society of Arts was in favour of the scheme, as was the Lord Mayor of London, and

industrialists and manufacturers from all over the country rallied to the cause. Municipal support came after the Prince had given a dinner at the Mansion House for 82 mayors of provincial towns in industrial districts. Financial problems were overcome by guarantees from individuals and firms against any losses which might be incurred, the Duke of Wellington heading the list of subscribers.

The task of choosing the architect proved unexpectedly difficult. In one month 233 architects, 38 of them foreign, submitted designs, but none of them appealed to the Building Committee, which then produced a design of its own. It was not very inspiring, in spite of the fact that it incorporated many of the ideas filched from the designs that had been rejected. In the end it was Joseph Paxton (later to become Sir Joseph), head gardener to the Duke of Devonshire at Chatsworth and self-taught architect, who produced the spectacular but, above all, functional design, a glass building which was dubbed the 'Crystal Palace' by Douglas Jerrold in *Punch*. Paxton's original plan was roughly sketched on a piece of blotting paper while he was attending a railway enquiry at Derby, and was based on a conservatory that he had built to house a giant South American lily.

The construction of the Crystal Palace, on which 2,000 men were employed, was a triumph of ingenuity and hard work over shortage of time and the forces of nature—1,000 square feet of glazing were blown down in a gale—in addition to all the other problems that confronted the erection of such a large building. The Palace was made of glass, iron and wood. All the pieces were bolted, screwed or slipped into place, no mortar or putty being used at all. As Prince Albert remarked in his opening address: 'It is a building entirely novel in its construction, covering more than 18 acres, 1,851 feet

17

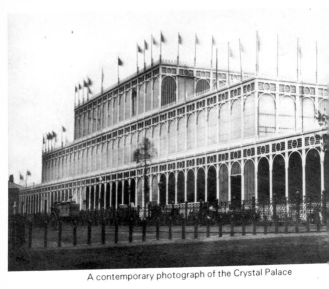

A contemporary photograph of the Crystal Palace

long and 456 feet wide, capable of containing 40,000 visitors, and offering a frontage for the exhibition of goods to the extent of more than ten miles.' Paxton's graceful palace of glass housed 33 million cubic feet, creating interior daylight over the whole of the enclosed area, and the trees of Hyde Park were allowed to flourish intact.

The building required one-third of the entire glass output of Britain for a year. The girders were painted cobalt blue, scarlet curtains were hung, and miles of gas pipes were laid to light the building at night. Thirty-four miles of pipes took away the rain from 18 acres of roof, from which flew the flags of all nations.

The Exhibition opened on 1 May 1851, and it was a very splendid occasion. The Queen, in a pink dress of watered silk brocaded with silver, with diamond

ornaments and the Garter Orders, declared the Exhibition open after the Prince had given his address, and 25,000 people cheered and applauded. A salute of guns was fired on the north side of the Serpentine, and not a pane of glass was cracked. The 'Hallelujah Chorus' was sung by five choirs, then the Queen, accompanied by her two eldest children, Princess Victoria and the Prince of Wales, led a procession of notabilities on a tour of the building.

Later the Queen declared that the event was superior even to her Coronation, and was the happiest and proudest day of her life, principally because her dearest Albert had been vindicated and his name immortalised. During the six months the Exhibition was open it attracted more than six million visitors, one of which was a baby born on the premises. More than 15,000 exhibitors participated, and £20,000 was distributed in prize money. The Queen and the Prince went to Hyde Park three days a week, 29 times in all, and every visit increased their enthusiasm.

The British exhibits were organised into four main divisions: raw materials, machinery and mechanical inventions, manufactures, and sculpture and the arts. Raw materials did not provide much of interest, though among the foodstuffs champagne made from rhubarb stalks had a certain outlandish quality. The most elegant exhibits in the machinery section were the carriages, and the railway era was strongly represented. There was a model of a suspension bridge for a railway between England and France, and another of a London which had a railway in the streets. The section also included architectural and building contrivances and examples of civil engineering, ranging from an embryonic aeroplane and a self-propelling rotary balloon to an artificial nose. Among the many ingenious inventions

Tudor-style terracotta chimney pots, by Doulton, from an engraving for the Great Exhibition catalogue

there was a patent submarine helmet, a model of the proposed Suez Canal, an electric table lamp, and an alarm clock called a 'servant's regulator'.

The third category, that of manufactures, included woollen and worsted goods, leather and skins, tapestry, lace and embroidery; and here imagination ran riot. A baby's knitted robe contained 1,464, 859 stitches made from 6,300 yards of cotton, and the Society for Promoting the Scriptural Education of the Native Irish sent a carpet specially woven by 150 ladies. Among the hardware were a gas stove, a shower bath, a washing machine, and an alarm clock which fired a pistol. Fantasy was also predominant in the furniture section, the highlight probably being a commode of various woods, the panels ornamented with marquetry and carvings. There was painted china in the centre, and the whole thing was furnished with rich gilt mouldings.

Marquetry table top, from an engraving for the Great Exhibition catalogue

The fine arts section showed no less evidence of ingenuity, technical innovation and opulence, though an excess of ostentation and absence of taste would have made it something of a nightmare to a visitor from the 1980s, a nightmare softened, however, by wry enjoyment of the absurd, the fantastic and the unorthodox. It would have been difficult to choose between pyrography executed on a lime tree with a red-hot poker, egg shells with views carved inside, or a model of St Paul's Cathedral made from cardboard. From the Elkington factory came a table of gold and silver electro-plate, and a particularly elaborate brooch was composed of 908 diamonds and 15 rubies which formed the setting for a figure of Britannia, who stood on a shell within a Gothic niche enriched with columns of carbuncle, and three pearl drops hanging from a winged dragon.

Statues, such as those of Queen Victoria and the future King Edward VII, were particularly uninspired, and there was a preponderance of standard classical themes. Shakespeare and Milton were overdrawn on for subjects, and Cupid turned up all over the place.

Most of the richness and colour came from the colonies and foreign countries. The East Indies sent gorgeous carpets, silks, ivory, jewels, spices, dyes and woods. Model locomotives came from Canada; tobacco and preserved peaches from America, and the pistol with the revolving chamber invented by Samuel Colt, not to mention an ice-making machine and a model of the floating church that drifted down the Delaware river. Brazil sent a bouquet of 'flowers' made from the feathers of exotic birds. The Sèvres china, Gobelin tapestry and textiles from France were greatly admired, as was the Bohemian glass from Austria. Cossack armour, leopard and tiger skins were among Russia's contributions; Germany sent a steel gun of F. Krupp; there were cameos and sculpture from Italy, lace from Belgium, marble from Greece, and from Spain jewelled weapons and a table inlaid with three million pieces of wood to represent a bullfight.

Later generations have applied unflattering epithets to much of the general standard of design, but even at the time William Morris and Cardinal Newman were severe critics; so was *The Times*. But the vast majority of visitors were lavish with their praise. Size, magnificence and costliness impressed the crowds who thronged the Crystal Palace day after day. They gasped at the Koh-i-nor diamond in its gilded cage, the largest mirror in the world, the huge Crystal Fountain, the gigantic statue of Richard Coeur-de-Lion, the solid lump of gold weighing over 300 pounds, the vast organ in the concert hall, and the stained glass windows of sacred art.

Parian figures—'Puck throned on a mushroom'—from
an engraving for the Great Exhibition catalogue

Though the quality of the exhibits was open to
question, there was no doubt about the sumptuousness
of their design; and the overblown decoration gave
point to the Archbishop of Canterbury's prayer at the
opening ceremony in which he stated that 'peace is

within our walls and plenteousness within our palaces'.

Whatever else it did, the Great Exhibition made the Victorian Englishman take a dispassionate view of his progress in industry and the arts, and it curbed his insularity and contempt for foreigners. Soon after it closed on 15 October, a profit of £186,000 was announced, part of which was used to buy 70 acres of land around the present Exhibition Road in Kensington, where now stand the museums and colleges established for the furtherance of the Arts and Sciences, and the Hall built in memory of him from whom the whole idea sprang.

In 1852 the Crystal Palace was moved to a commanding hill at Sydenham in south London, where it remained until it burned down in 1936. Concerts were held there, so were brass band competitions; oratorios performed by massed choirs were very popular, and over the years other attractions included firework displays, roller-skating, football, bicycle racing, and many sporting contests.

Towards the end of its life the Crystal Palace was not paying its way. It would have been practically impossible for so much glass to have been blacked out during the blitz of the Second World War, so perhaps its somewhat ignominious end was the best thing that could have happened. But how Queen Victoria would have wept.

2 VICTORIAN ARCHITECTURE

Up to the beginning of the nineteenth century the history of English architecture was in essence a story of order, discipline and continuity. At any time there was a general style applicable to all buildings. Architecture was based on tradition and new features were quickly absorbed into the pattern. All that was changed, however, as the Victorian era advanced, and it is impossible to speak of Victorian architecture without including a number of styles, each with its variations, which were in vogue at the same time.

From about 1640 to 1830 all English architecture was based on that of Greece and Rome, but it was inevitable that people should become tired of the conventions of classicism, and the answer to the need for change was Gothic, the architecture of the period from c. 1200 to c. 1550. This desire for something different was stimulated by the romantic revival in literature and poetry as exemplified by Scott and Byron, by a growing nationalism, and by the religious movement for 'christianising' church architecture.

In 1818 Parliament voted a million pounds towards building new Anglican churches, and in 1824 another half million, and out of the 214 churches which were built 174 were in a Gothic or near-Gothic style. Many were cheap-looking and uninspiring, and display was confined to a portico or tower at the west end. The rest was a brick box with a gallery, closed-in pews and no proper chancel.

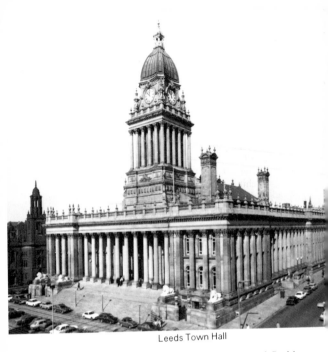
Leeds Town Hall

Though the scales were turning in favour of Gothic, Italian Renaissance or Roman architecture continued to be favoured for public buildings. Between 1815 and 1858 St George's Hall in Liverpool, Leeds Town Hall, Birmingham Town Hall and the Reform Club in London, all characteristic examples of the old style, were built. In 1834 the Houses of Parliament were built to a Gothic design by Barry and enlivened by Pugin's details. Even when the battle of the styles began in earnest, Barry continued to design in the classic and Gothic manner with equal facility.

Augustus Welby Northmore Pugin, in his book *Contrasts* (1836), called for a return to medieval standards of life and art, and advocated structural design as distinct from the design of façades. Pugin was called the most eminent and original architectural genius of his time. His romantic passion for Gothic glories was enthusiastically taken up by two important bodies, the Anglicans of the Oxford Movement, and the Cambridge Camden Society, later called the Ecclesiological Society. They asserted that thirteenth-century church architecture was the only style that fitted the requirements of Christian worship. The Catholic Emancipation Act of 1829 gave further impetus to the wave of church building. Pugin himself designed 65 churches, in addition to convents, monasteries and schools, and his influence was maintained by his writings as well as by his work.

In their efforts to 'improve' and 'restore' existing churches the Gothic enthusiasts did some terrible things. Many old parish churches were gutted and all that survived from medieval times was destroyed. High box pews and the three-storeyed pulpit disappeared, chancels were raised, floors tiled and whitewash scraped away, thus destroying many wall-paintings. Pitch-pine pews were installed in the chancel to accommodate the new-fangled choirs, and the sanctuary was adorned with stained glass of dubious merit.

Sir George Gilbert Scott (1811–78), an ardent disciple of Pugin, became the autocrat of restoration and, in spite of his natural facility and talent, managed to mutilate hundreds of churches and nearly every cathedral he touched.

In secular architecture the battle of the styles continued for many years, reaching its climax over the competition for a design for a new Foreign Office. Lord

Palmerston opposed Scott's Gothic design, and Scott, with the assistance of M. Digby Wyatt, had to convert it into an Italian form. Scott is said to have used his rejected elevations on St Pancras Station. An uneasy compromise existed until the end of the century. Gothic Revival was still favoured for churches, but public buildings were often in the form of Greek or Roman temples, and many of them turned out to be debased and uninspired.

The second phase of the Gothic revival was largely inspired by John Ruskin, who eulogised medieval Italian architecture in his book *The Stones of Venice*, though it is difficult to reconcile his advocacy of simplicity with his medieval taste. From mid-century Gothic styles had a distinctly foreign flavour and were far removed from the English revival of Pugin. Even the classical school was not exempt from French or Venetian mannerisms. The whole of the architectural scene was, in fact, without direction or continuity. Planning, convenience and economy were sacrificed for external effects. Ornament became an end in itself and decoration ran riot, our cities becoming a medley of unrelated façades.

With the growth of industrialism and the improvement in communications, the technical problems involved in the building of railways, stations, canals, bridges and factories were solved by engineers rather than by architects, and as architects dissociated themselves more and more from industrial design the engineers had to take over. Fortunately, a few great engineers were gifted with a sense of form. They produced magnificent structures with daring new characteristics, such as the arched iron and glass roof and the glass and iron wall. The roofs of King's Cross Station and Paddington Station and the lines of

Chepstow flat girder bridge are clean and elegant, and are unencumbered by nostalgia for any period of the past. The greatest success of the 'engineering school' was Paxton's Crystal Palace, but unfortunately the clear logic of his design had only a minimal effect on current architectural styles. Exuberance and vulgarity, so much on show inside the Palace, were equally rampant on the architectural scene outside.

After the middle of the century there was, in some quarters, a movement towards simplification and unity of design. William Morris advocated a sane style on logical lines, and his ideas led to the garden city houses later built at Letchworth and Welwyn.

St Pancras Station and Hotel, London

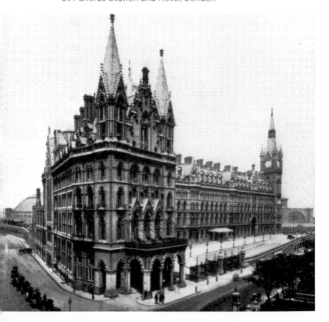

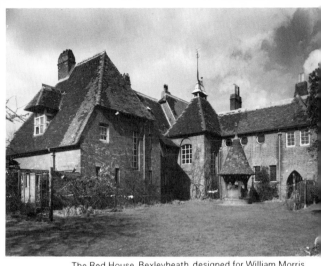

The Red House, Bexleyheath, designed for William Morris
by Philip Webb

Town planning was not a prominent feature of the
nineteenth century, but was largely a survival from the
eighteenth. London's Regent Street and the towns of
Cheltenham and Leamington are pre-Victorian. It was
not until near the end of the century that slum clearance
became imperative. George Cadbury built the model
village of Bournville, thus laying down the basis of
modern town planning, and other paternally-minded
industrialists followed his example, though they could
only touch the fringe of the problem.

Improvements in housing, drainage and water sys-
tems were slow to be started, but great strides were
made when Parliament became active in passing
legislation. The old 'back to back' houses were con-
demned. Water closets, even baths, were not as scarce
as they had been, at least in urban areas. Slums are still

with us, but they are not as noisome as they were when living in a cellar without light or ventilation was common, or when the poor slept in layers in rotting tenements.

For the middle classes the villa was the desired residence. It was made of brick and was overloaded with Gothic details in stone or stucco. The streets of the suburbs of big cities were lined with small houses with bay windows, Gothic pillars with moulded capitals and steeply pointed roofs with spiky tops. There was also a craze for the half-timbered house. The style plumbed the depths when ordinary boarding was stuck on to brickwork to imitate timber. The speculative builder and the amateur architect were responsible for so many fancy and individual styles that it is impossible to generalise about end-of-century housing, except to say that it was capricious, charmless and dull.

In fact the whole Victorian architectural scene was dominated by the solemn, the ponderous and the over-elaborate. Buildings resembled their medieval counter-parts in everything but beauty and elegance. They were designed by men who ignored the fact that the medieval spirit was alien to a totally different age. They chased a shadow without bringing back the substance.

The following is a list of the most prominent Victorian architects and a representative selection of their buildings which still survive.

Sir Charles Barry (1795–1860)
Reform Club, Pall Mall, London 1837–41
Houses of Parliament, London 1837–67
City Art Gallery, Manchester 1824–35
Travellers' Club, Pall Mall, London 1829–32
Royal College of Surgeons, Lincoln's Inn Fields, London 1835

Pentonville Prison façade, London 1841
Halifax Town Hall 1859–63

Charles Barry, Junior (1823–1900)
Dulwich College, London 1866–70
Front of Burlington House, Piccadilly, London
 1869–73

Edward Middleton Barry (1830–1880)
Royal Opera House, Covent Garden, London 1857
Charing Cross Station Hotel, London 1864

George Basevi (1794–1845)
Fitzwilliam Museum, Cambridge 1837–45

The Fitzwilliam Museum, Cambridge

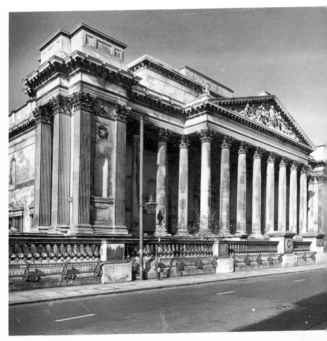

Sir Joseph William Bazalgette (1819–1891)
Thames Embankment, London 1862–74
Hammersmith Bridge, London 1884–7

Cuthbert Brodrick (1822–1905)
Leeds Town Hall 1853–8
Corn Exchange, Leeds 1861–3
Grand Hotel, Scarborough, Yorks. 1863–7
Mechanics' Institute, Leeds (now Art School) 1865

Isambard Kingdom Brunel (1806–1859)
Clifton Suspension Bridge, Bristol 1829
Great Western Hotel, Bristol 1837
Temple Meads Station, Bristol 1839–40
Paddington Station, London (with M. D. Wyatt)
 1852–4

David Bryce (1803–1876)
British Linen Company's Bank, Edinburgh 1846–51
Bank of Scotland, Edinburgh 1864–70
Post Office, College Green, Dublin 1868
Fettes College, Edinburgh 1863–70

William Burges (1827–1881)
St Finn Bar Cathedral, Cork from 1863
Cardiff Castle 1868–81

Decimus Burton (1800–1881)
Athenaeum Club, Pall Mall, London 1829–30
Palm House, Kew Gardens 1844–8
Museum, Kew Gardens 1856–7

William Butterfield (1814–1900)
Keble College, Oxford 1867–83
Balliol College Chapel, Oxford 1854–7
All Saints' Church, Margaret Street, London (with
 vicarage and choir school) 1850–59

St Alban's Church, Holborn, London (only Butterfield's
tower survives) 1859–62
College of St Augustine, Canterbury 1844–73
St Dunstan's Abbey, Plymouth from 1850
Royal Hampshire County Hospital, Winchester
1863–8
St Mark Dundela, Belfast 1876–91
Exeter Grammar School 1877–87
St Paul's Anglican Cathedral, Melbourne,
Australia 1877–91

All Saints'
Church,
Margaret
Street,
London

Richard Cromwell Carpenter (1812–1855)
Lonsdale Square, Islington, London 1838–42
St Mary Magdalene, Munster Square, London 1849–52
Lancing College, Sussex from 1854

Charles Robert Cockerell (1788–1863)
University Library, Cambridge 1836–42
Ashmolean Museum and Taylorian Institute, Oxford 1841–5
St George's Hall, Liverpool (completed) 1847–56

Lewis Cubitt (1799–1883)
King's Cross Station, London 1851–2

Captain Francis Fowke (1823–1865)
Raglan Barracks, Devonport, Plymouth 1859–60
National Gallery, Dublin 1859–60
Royal Scottish Museum, Edinburgh 1860–61
Royal Albert Hall (design) 1864

Edward William Godwin (1833–1886)
Northampton Town Hall 1860–64
Congleton Town Hall 1865–7
Dromore Castle, Limerick 1866–73
Anderson's Warehouse, Bristol 1862
Guildhall, Plymouth 1870–74

Joseph Aloysius Hansom (1803–1882)
Birmingham Town Hall from 1832

Philip Hardwick (1792–1870)
Goldsmiths' Hall, Foster Lane, London 1829–35
Curzon Street Station, Birmingham 1838
Hall and Library, Lincoln's Inn, London 1843–5

Philip Charles Hardwick (1820–1890)
Great Western Hotel, Paddington, London 1851–3

Charterhouse School, Surrey 1865–72

Thomas Chambers Hine (1813–1899)
Corn Exchange, Nottingham 1850
Bentinck Memorial, Mansfield, Notts. 1849

Sir Thomas Graham Jackson (1835–1924)
New Buildings, Brasenose College, Oxford 1880–89,
 1909–11
Giggleswick School Chapel, Yorks. 1897
Examination Schools, Oxford 1876–82

Sir Horace Jones (1819–1887)
Smithfield Market, London 1866
Temple Bar Memorial, London 1880
Leadenhall Market, London 1881
Tower Bridge, London 1886–94

Alexander Kirkland (c. 1824–1892)
Suspension Bridge, Glasgow 1851

John L. Leeming (1849–1931)
Admiralty, Whitehall, London 1884, 1894–5

Henry Francis Lockwood (1811–1878)
St George's Hall, Bradford 1851–2
Bradford Town Hall 1869–73

Frank Matcham (1854–1920)
Grand Theatre, Blackpool 1894
Hippodrome, London 1899–1900
Grand Opera House, Belfast 1895

Edward William Mountford (1855–1908)
Sheffield Town Hall 1890–97
Battersea Town Hall, London 1892
Central Criminal Court, London 1900–07

Sir Joseph Paxton (1803–1865)
Mentmore Towers, Bucks. (with G. H. Stokes) 1851–4
Victoria Regia Lily House, Chatsworth, Derbys.
 1849–50
Model Village, Edensor, Derbys. from 1838
Princes Park, Liverpool 1842–4

Sir James Pennethorne (1801–1871)
Public Record Office, London 1851
West Wing, Somerset House, London 1852–6
Ballroom, Buckingham Palace, London 1853–5

John Charles Phipps (1835–1897)
Theatre Royal, Nottingham 1865
Savoy Theatre, London 1881
Her Majesty's Theatre, London 1891–5

Augustus Welby Northmore Pugin (1812–1852)
St Barnabas' Cathedral, Nottingham 1841–4
St John's Hospital, Alton, Staffs. from 1840
St Chad's Cathedral, Birmingham 1839–41
St Augustine's Church, Ramsgate, Kent 1845–51
Scarisbrick Hall, Lancs. 1837–45
Catholic Cathedral of St George, Southwark, London
 (mostly demolished) 1840–48
St Mary's Cathedral, Killarney from 1842

Anthony Salvin (1799–1881)
Thoresby Hall, Notts. 1864–75

Sir George Gilbert Scott (1811–1878)
Government Offices, Whitehall, London 1863–73
Albert Memorial, Kensington, London 1863–72
St Pancras Station and Hotel, London 1865–74
Chapel of St John's College, Cambridge 1863–9
St Mary Abbots Church, Kensington, London 1869–
 72

Exeter College Chapel, Oxford 1856–60
Martyrs' Memorial, Oxford 1841–4
Reading Gaol 1842–4
Workhouse, Great Dunmow, Essex 1840
Kelham Hall, Notts. 1858–61
Leeds Infirmary 1864–8
Glasgow University 1865, 1868–71
Episcopal Cathedral, Edinburgh 1874–9

George Gilbert Scott, Junior (1839–1897)
New Building, Pembroke College, Cambridge 1879

John Pollard Seddon (1827–1906)
University College, Aberystwyth (built as hotel)
 1864–90
St Paul's, Hammersmith, London (with H. R. Gough)
 1880–88
Powell Almshouses, Fulham, London 1869

John Shaw (1803–1870)
Goldsmiths' College, London 1843–4
New buildings, Eton College, Berks. 1844–6
Wellington College, Berks. 1856–9

Richard Norman Shaw (1831–1912)
New Scotland Yard, London 1887–90, 1900–07
Albert Hall Mansions, Kensington Gore, London
 1879–86

Sir Robert Smirke (1781–1867)
British Museum, London 1823–47

Sydney Smirke (1798–1877)
Reading Room, British Museum 1854–7
Imperial War Museum portico and dome 1838–46
Conservative Club, St James's, London (with
 Basevi) 1843–5

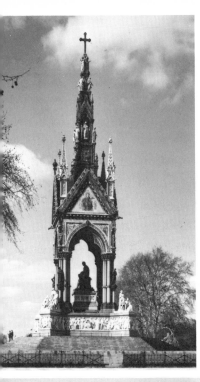

(left)
The Albert
Memorial,
London

(below)
Wellington
College,
Berkshire

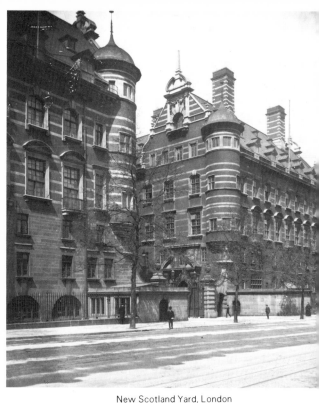

New Scotland Yard, London

Brookwood Cemetery, near Woking, Surrey (with Tite) 1854–6

Robert Stephenson (1803–1859)
Britannia Bridge, Menai Straits 1845–50
Round House, Chalk Farm, London (Engine house turned theatre) 1847

George Edmund Street (1824–1881) and
Arthur Edmund Street (1858–1938)
St James the Less, Westminster, London 1859–61
St Mary Magdalene, Paddington, London 1867–73
Law Courts, London 1874–82
Crimea Memorial Church, Istanbul 1863–8
American Church, Paris 1880–1906

Sir William Tite (1798–1873)
Royal Exchange, London 1841–4
Perth Station 1848
Windsor Station 1851

Charles Harrison Townsend (1851–1928)
Bishopsgate Institute, London 1892–4
Whitechapel Art Gallery, London 1897–9
Horniman Museum, London 1898–1901

Frank Thomas Verity (1864–1937)
Criterion Theatre, London 1870–74
Comedy Theatre, London 1881
Nottingham Guildhall 1884–8

Edward Walters (1808–1872)
Free Trade Hall, Manchester 1853

Alfred Waterhouse (1830–1905)
Assize Courts, Bedford 1878
Manchester Town Hall 1868–77
Natural History Museum, London 1873–81
Strangeways Gaol, Manchester 1866–8
Gonville and Caius College, Cambridge 1868
Girton College, Cambridge 1872
Royal Infirmary, Liverpool 1886

Sir Aston Webb (1849–1930)
Assize Courts, Birmingham 1886–95
Christ's Hospital, Horsham, Sussex 1893–1902

Sir Matthew Digby Wyatt (1820–1877)
Addenbrooke's Hospital, Cambridge 1864–5
India Office (interior), Whitehall, London 1867

Thomas Henry Wyatt (1807–1880)
Liverpool Exchange 1865
Norfolk and Norwich Hospital, Norwich 1879
St Andrew's, Bethnal Green, London 1841

William Young (1843–1900)
City Chambers, Glasgow 1883–8
War Office, Whitehall, London 1898

3 VICTORIAN PAINTING

From about 1810 up to the 1840s painting in Britain was chaotic—a mixture of various artistic traditions and styles, all accepted as having their own worth. The conservatism of the Royal Academy was stiflingly strong but there were departures and modifications in several directions. Genre painting, derived from Flemish and Dutch artists, reflected the smug, homely world of the Victorian middle classes and was highly approved of by patrons who enjoyed improving pictures with a moral attached. Sir David Wilkie (1785–1841) was a leader of the genre school, presenting the age as people wanted to see it: prosperous, godly and content. It was the anecdotal content of his pictures that was so admired; the fact that the paintings themselves were commonplace was not important.

Landscape and watercolour painting was another British tradition with its roots in the previous century, and it was a medium in which British painters felt at home. It fitted in well with the national taste for the open air and the pursuits of the countryside. David Cox (1783–1859), Peter de Wint (1784–1849) and John Sell Cotman (1782–1842) are the great names in watercolour landscapes; Cotman in particular produced many exquisite works. Cotman and John Crome helped to establish the Norwich School, which owed much to Dutch seventeenth-century landscape painting.

Joseph Mallord William Turner (1775–1851) is the outstanding figure of the times, and was the most

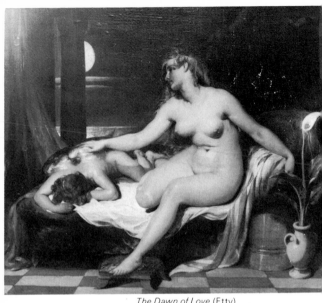

The Dawn of Love (Etty)

prolific, producing many thousands of works, intensely personal and original variations on the style of past artists. He was a Londoner who travelled widely. He venerated the tradition of European landscape painting, and the variety and breadth of his observation of natural phenomena amazed his contemporaries, as it amazes us.

John Constable (1776–1837) liberated art from the confines of the Royal Academy with his landscapes which are unique in the history of art. He was a countryman who could only paint scenes for which he had a deep affection, taking for his subjects the everyday life of the countryside. In his time he was a truly radical artist, trying to enshrine in his paintings the shifting

quality of English weather as it affected the natural scene, and he was subjected to both apathy and harsh criticism from the upholders of tradition.

Early in the nineteenth century there was also a strange group of eccentric artists, individualists with apocalyptic feelings. They had little influence on their contemporaries, but they stand out today as peaks rising from the mist of mediocrity: James Barry (1741–1806), Henry Fuseli (1741–1825) and, most impressive of all, William Blake (1757–1827). Poet and mystic as well as painter, he engraved, and sometimes coloured by hand, many of his own literary works. A devoted admirer of Blake was Samuel Palmer (1805–81), landscape painter and etcher, who first exhibited at the Royal Academy at the age of fourteen.

In portraiture Sir Henry Raeburn (1756–1823) continued the grandiose traditions of the eighteenth century, and Sir Thomas Lawrence (1769–1830), courtier-painter, added glitter and polish to a superficial talent. William Etty (1787–1849) painted faithful studies of the nude in rich and satisfying, almost Venetian, colours. Benjamin Robert Haydon (1786–1846) tried to revive the vogue for historical paintings, but succeeded only in making popular the type of anecdotal painting that, produced by far less capable hands, lasted until the end of the century.

Thus, in the early years of the century, styles and subject-matter varied widely. There was a lack of certainty, a fruitless search for guiding principles. It was not until the Pre-Raphaelites burst on the art scene in 1848 that a new seriousness and higher standards changed everything. The movement was a reaction against both the eighteenth century and the spirit of its own time. The pictorial conventions typified in the Royal Academy exhibitions, dominated by realism,

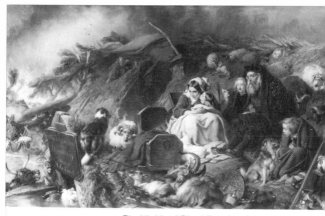

The Highland Flood (Landseer)

incident and detail, were rejected. Sir Joshua Reynolds was scorned. So were the homely anecdotes of the genre school. Sir Edwin Landseer (1802–73), Queen Victoria's favourite painter, with his humanised animals, was held up to ridicule. The Pre-Raphaelite Brotherhood, initially a secret society of young artists, was formed by Dante Gabriel Rossetti (1828–82), William Holman Hunt (1827–1910) and John Everett Millais (1829–96). They sought their inspiration from the Middle Ages, from a desire to return to the principles and practice of an age of faith and to recover clarity of form and nobility of sentiment. They took as their model the Nazarenes, a brotherhood of German painters based in Paris, who followed an austere rule and painted in an austere style. Daniel Maclise (1806–70) and William Dyce (1806–64), a Scottish painter, were also influenced by the Nazarenes, as were Ford Madox Brown (1821–93) and Arthur Hughes (1832–1915). The poetic principles of Wordsworth were a spur to the Pre-Raphaelites, and 'Truth to Nature' was their rallying call. They were also deeply

46

influenced by John Ruskin (1819–1900), who wrote *Modern Painters* and exhorted artists to study Nature reverently.

The Pre-Raphaelites painted in oils but returned to the earlier technique of fresco, and treated detail with incredible minuteness, and their works had a brightness and luminosity that could be breathtaking. As time went on their outlook and methods diverged. Rossetti was always wrapped up in medievalism. Spiritually and emotionally it satisfied him, and he had little real feeling for Nature and religion. Holman Hunt, on the other hand, developed a strong religious bias. He spent long periods in the Holy Land. Millais became involved in the techniques of painting rather than the subject-matter, put aside the intellectual severity he had formerly embraced, and painted clever, sentimental pictures that were very popular and sold at high prices.

Although the original tight-knit band of artists lost their purpose and abandoned the restrictions they had imposed on themselves, their influence by no means faded away. Their revolt was supported by other artists who remained loyal to Pre-Raphaelite principles, and the movement continued to stimulate good works by minor artists. The disciples of a second phase, which began in 1857–8, included William Morris (1834–96) and Edward Burne-Jones (1833–98). Burne-Jones was the greatest painter of this later movement, superior in talent and technique to Rossetti, whose visionary mysticism was by now becoming almost a parody of itself.

While the Pre-Raphaelites were flourishing, and while the traditionalists were being handsomely supported by the merchant class and the *nouveau riche*, a new style of painting was developing in France, where the old order had been swept away by the French

Revolution. There was no longer an aristocracy, and the artificial style of the eighteenth century had gone. Courbet, followed by Manet and the Impressionists, became independent in both subject and style. Whereas the Pre-Raphaelites worked from the particular to the general, the Impressionists worked in the opposite way. Instead of depicting each leaf minutely to give the effect of a mass of foliage, they painted a general impression of the mass under various aspects of light, which itself was given a vibrant, shimmering quality. Landscape was treated as a single vision seen in a flash. Far from wishing to recapture the spirit of the Middle Ages or to advocate social reform, the French painters were artists pure and simple. They were absorbed in their own work, aloof from and indifferent to the rest of society. Their creed was 'Art for Art's sake'.

James Abbott McNeill Whistler (1834–1903) was the first artist to act as intermediary between the painters of Britain and France, and to persuade Britain to give up isolationism in art. He left America for France in 1855, and came to London in 1859, where he spent most of his time. In London he produced an exquisite series of Thames etchings. In the 1850s he had absorbed the realism of Courbet, and he joined with his friend Rossetti in collecting Oriental art objects. He became deeply interested in Japanese art, with its insistence on design and arrangement, tone and colour in composition, and its indifference to subject-matter. He roused the ire of Ruskin and the opposition of both the Pre-Raphaelites and the academic school. He attacked the idea that a picture should tell a story or have a moral purpose, and he insisted that the artist had no responsibility to the social conditions of the people. He believed that a picture should stand or fall on the way it is designed and painted. His painting was beautifully balanced and

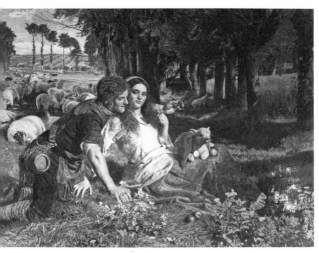

(above)
The Hireling Shepherd
(Holman Hunt)

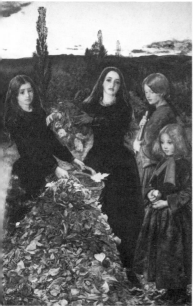

(left)
Autumn Leaves
(Millais)

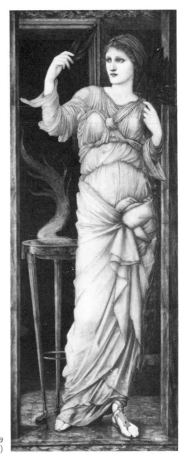

Sibylla Delphica
(Burne-Jones)

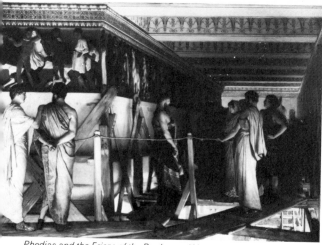

Phedias and the Frieze of the Parthenon (Alma-Tadema)

harmonious, and he produced etchings, lithographs, pastels and watercolours of great delicacy.

George Moore, friend of Manet and Degas, spoke up in terms similar to Whistler's, and the Pre-Raphaelites began to feel uneasy, even inferior. Their beliefs were being questioned, not by philistines, but by artists, writers and men of vision. They had to come to terms with the idea that the painter must become exclusive, shunning the ways of ordinary men, with no social or economic conscience. An artist was a 'genius', answerable to nobody. From being a wealthy professional serving the middle classes he must become a solitary, serving only himself. It was a new, frightening concept.

It must be remembered, however, that in the midst of the heart-searching, the arguments and the questions, the members of the Royal Academy painted on, scornful of, if not oblivious to, the painful stirrings of modernism. They countered them by a return to classicism, a greater

51

sentimentality, and what seemed a deliberate refusal to stretch their vision. Frederick Lord Leighton (1830–96), President of the Royal Academy in 1878, took his subjects from Greek and Roman sources, and although his work was accomplished and tasteful, he was working in a dead tradition. Lawrence Alma-Tadema (1836–1912), a Dutchman, also specialised in Greek and Roman subjects, and was famous for his exact rendering of textures and surfaces. Alfred Stevens (1817–75) revived the Italian Renaissance spirit of Michaelangelo and Raphael, but he never realised his full potential as his energies spilled over into sculpture and decoration. Edward John Poynter (1836–1919) was also associated with the classical revival. G. F. Watts (1817–1904) was a good portrait painter who stood apart from movements and fashions but is best known for his paintings of allegorical themes. His vision was truly cosmic; he attempted to illustrate the hopes and tragedy of man in the universe. W. P. Frith (1819–1909) faithfully representated everyday scenes of the life of his times in great detail, beautifully executed.

The products of these artists were bought by city councils to add lustre to their new art galleries, as well as by private individuals, and annual exhibitions were held in various cities. Hard-headed and self-opinionated captains of industry expected artists to toe the line they laid down, and the artists obeyed, endlessly producing their versions of pathetic children begging in the snow, dogs pining at their master's grave, and Christians defying the lions.

In 1886 the New English Art Club was formed. It consisted chiefly of British artists who had been trained in France, and their original aim was to follow the French Impressionists by painting objects from Nature under effects of light. In the course of time various

groups split off from the parent body—the Newlyn School in Cornwall and the Glasgow School, for instance—but the Club continued to flourish strongly and the dominance of the Royal Academy was threatened. A further threat was the growing influence of the Slade School, founded in 1871 with Poynter as its first professor.

Two of the leading members of the New English Art Club were Philip Wilson Steer (1860–1942) and Walter Richard Sickert (1860–1942), both of them exponents of Impressionism in Britain. Steer excelled in watercolours and oil sketches, his work being slight but fluent, his technique of classic excellence. Sickert, a pupil of Whistler, was, in spite of the influence of his friend Degas, a marked individualist. He painted landscapes but excelled in 'mood of the moment' scenes from life, and his paintings of British music hall and north London interiors are among his most striking works.

At the end of the nineteenth century the ferment of new ideas which so strongly affected music and poetry had no less an impact on painting. Impressionism had never completely taken root in English soil, and though the relationship with the Continent had always been significant, British genius was fundamentally alien to it. Impressionism was refined, delicate and suggestive. British artists felt the need for more strength and solidity. A new principle was needed, and the lead again came from France. There Cézanne, van Gogh and Gauguin became the Post-Impressionists, and the movement had an invigorating effect on British painters, though the explosion did not come until 1910 and 1912 when Roger Fry organised exhibitions at the Grafton Galleries in London. Though public reaction was hostile, the impetus for which painters had been searching was excitingly revealed. With Augustus John and the

members of the Bloomsbury School, the Camden Town Group and the London Group a new era in British painting began.

The works of the principal Victorian painters can be seen at the following art galleries:

Aberdeen *Art Gallery*
Nineteenth-century artists' self portraits
Bedford *Cecil Higgins Art Gallery*
Pre-Raphaelites, William Dyce
Birkenhead *Williamson Art Gallery*
Wilson Steer
Birmingham *City Museum and Art Gallery*
Pre-Raphaelites, Sickert, Wilson Steer
Bolton Museum and Art Gallery
Victorian watercolour artists, Millais
Bournemouth *Russell-Cotes Art Gallery and Museum*
Rossetti, Etty, Frith, Landseer
Bradford *City Art Gallery*
Etty, Ford Madox Brown
Brighouse *Art Gallery*
Wilkie, Millais, Frith, Leighton
Bristol *City Art Gallery*
Etty, Millais, Burne-Jones, Watts, Leighton
Cambridge *Fitzwilliam Museum*
Pre-Raphaelites, Alma-Tadema, Leighton, Sickert, Wilson Steer
Cardiff *National Museum of Wales*
Burne-Jones, Frith, Whistler, Alma-Tadema
Carlisle *Museum and Art Gallery*
Leighton, Watts, Rossetti, Burne-Jones
Dublin *National Gallery of Ireland*
Nineteenth-century Irish painters
Dundee *City Art Gallery* .
Nineteenth-century Scottish painters

Edinburgh *National Gallery of Scotland*
Nineteenth-century painters
Glasgow *Art Gallery and Museum*
Nineteenth-century Scottish painters, Glasgow School
Glasgow University *Hunterian Museum*
Whistler
Guildford *Watts Gallery, Compton*
G. F. Watts
Leeds *City Art Gallery*
Millais, Sickert, Wilson Steer
Leicester *Art Gallery*
Dyce, Etty, Leighton, Frith, Watts
Lincoln *Usher Gallery*
Peter de Wint
Liverpool *Sudley Gallery*
Landseer, Leighton, Pre-Raphaelites
Liverpool *Walker Art Gallery*
Wilkie, Landseer, Pre-Raphaelites, Watts, Leighton, Sickert
London *Leighton House Art Gallery*
Leighton, Alma-Tadema, Burne-Jones, Ford Madox Brown, Millais, Watts
National Gallery
Turner, Constable
National Portrait Gallery
Millais, Watts, F. M. Brown, Rossetti, Landseer, Sickert, Steer
Tate Gallery
A comprehensive collection of all the major Victorian painters
Victoria and Albert Museum
Landseer, Frith, Watts, Pre-Raphaelites, Leighton
William Morris Gallery
Morris, Pre-Raphaelites

Manchester *City Art Gallery*
Etty, Wilkie, Leighton, Frith, major works of Holman Hunt and Ford Madox Brown
Manchester *Whitworth Art Gallery*
Nineteenth-century painters and tapestries designed by Morris and Burne-Jones
Newcastle upon Tyne *Laing Art Gallery and Museum*
Pre-Raphaelites
Norwich *Castle Museum*
Norwich School
Oxford *Ashmolean Museum*
Pre-Raphaelites
Paisley *Museum and Art Gallery*
Glasgow School
Plymouth *Museum and Art Gallery*
West Country artists, Haydon
Port Sunlight *Lady Lever Gallery*
Hunt, Millais, Leighton
Preston *Harris Museum and Art Gallery*
Sheffield *Graves Art Gallery and Mappin Art Gallery*
Southampton *Art Gallery*
New English Art Club
Southport *Atkinson Art Gallery*
Stalybridge *Astley Cheetham Art Gallery*
Swansea *Glyn Vivian Gallery*
Tunbridge Wells *Royal Tunbridge Wells Museum and Art Gallery*
Wolverhampton *Art Gallery*
Wilkie, Maclise, Frith, Landseer
York *Art Gallery*
William Etty

4 VICTORIAN CRAFTS

FURNITURE

For the first 30 years of the nineteenth century furniture in England was made in the main in what is called for convenience the Regency style, although Prince George was Regent only from 1811 to 1820. Before then classical times had inspired ornament rather than actual furniture, but now chairs, tables and couches were copied from those which were being excavated at Pompeii and other places. Their lines were bare, simple and formal. Greek vase paintings provided the principles for such severity, and the purchase of the Parthenon sculpture in 1816 gave further impetus to the ardour for all things Grecian.

The favourite woods were rosewood and mahogany, and brass inlay was a notable feature. Chairs had legs which curved outward, couches and sofas had flowing lines and rolled ends, and dining tables were supported by a single pillar with four splayed legs. A circular table might have a fluted pedestal mounted on three flat claws. Bookcases with copper wire screening were popular, and there was a profusion of black lacquer, gold banding and marble tops. There was a short vogue for ancient Egypt, influenced by French conquests in Egypt. Though the decline to the Victorian hotchpotch of clumsy over-elaboration began in the 1830s, the Georgian love of fine furniture lingered on, and many fine pieces of delicate design were made, providing faint echoes of past greatness.

Whatever the faults of early Victorian furniture, it was soundly and solidly constructed, and was made to last. The finest woods in the world were available, and there was a large labour force trained in the best standards of the craftsmanship of the previous century. This is borne out by the thousands of Victorian chairs, tables, chests of drawers and bureaux which still survive and serve a useful purpose.

Between c. 1835 and c. 1855 four main styles of furniture were prominent. According to Loudon's *Encyclopaedia of Cottage, Farm and Villa Architecture and Furniture*, published in 1833, they were 'the Grecian or modern style which is by far the most prevalent; the Gothic or Perpendicular style, which imitates the lines and angles of Tudor Gothic architecture; the Elizabethan style, which combines the Gothic with the Roman or Italian manner; and the style of the age of Louis XIV, or the florid Italian, which is characterised by curved lines and excess of curvilinear ornament'.

The Classical or Grecian style, based on Regency patterns, has already been mentioned. As a change from Greek severity, and in search for comfort rather than simplicity, the early Victorians became positively frivolous. The rococo designs of Louis XIV were widely popular, though more so with decorators than with architects. The style remained in vogue for special and very expensive pieces made for international exhibitions or for people who wanted the very best in craftsmanship.

The Elizabethan style was a mishmash of Tudor and Renaissance, solid and florid, the design secondary to the ornamentation, which consisted of roundels, swags of flowers, cupids and cherubs. Pugin, one of the few architects who also designed furniture, concentrated exclusively on Gothic lines, except for some in the

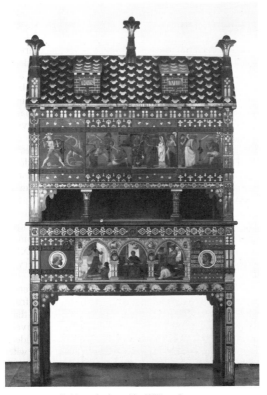

Cabinet designed by William Burges

houses he built in the 1840s. His influence was due chiefly to the furniture he designed for the Houses of Parliament and to a display piece for the Medieval Court of the Great Exhibition, both of which were copied extensively, though suffering from such architectural conceits as pinnacles, crockets, tracery and

gables. William Burges, another architect-designer, adapted medieval forms to an extreme degree, but was sometimes capable of restraint, and produced some plain pieces which depended for their success on the surface painting. A bookcase in the Ashmolean Museum in Oxford, and a cabinet in the Victoria and Albert Museum in London are untypically un-Gothic. Pugin's *Gothic Furniture* and Henry Shaw's *Specimens of Ancient Furniture* both helped to vulgarise nineteenth-century furniture.

It is important to realise that none of the styles categorised by Loudon was succeeded by another. They all existed at the same time, alone or in combination, though the Grecian died out first and the Louis XIV lasted longest. Sorting out one style from another is

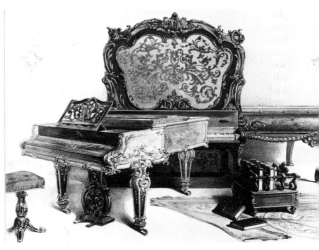

Piano exhibited at the Great Exhibition, from an engraving for the catalogue

further complicated when, after Queen Victoria's Golden Jubilee in 1887, Indian influences crept in, and later Japanese and other Oriental motifs became popular. Another factor to be considered is the time lapse between furniture made for the rich, the middle classes and the poor. By the time the styles favoured by the rich had filtered down to the poor there was a great gap. Cheap Grecian and Gothic products were being made long after the trend-setters had discarded them.

During the nineteenth century the craft of furniture-making became a very important industry. Machinery and mass production methods took over from the craftsman, whose work was then limited to the luxury trade. The quality of the wood used and the standard of workmanship were satisfactory but, as far as design was concerned, the period up to 1851 saw furniture in England at its lowest ebb. Victorian taste was thoroughly debased, and nadir was reached in the Great Exhibition of 1851. The ostentation and vulgarity of the exhibits were aggravated by the competition between manufacturers to produce furniture the like of which had never been seen before; indeed, much of it was never seen again. The copying of past styles was accompanied by such rich and elaborate carving that the original shape was almost completely smothered. There were many grandiose monstrosities on show at the Exhibition. Some of the worst were the 'Kenilworth Buffet' (a great sideboard carved with scenes from Scott's novel *Kenilworth*), a cradle that would have given nightmares to any baby, and some carved furniture in Irish bog oak.

After the Great Exhibition there was a marked change in furniture designs. Styles became much less confused, a consistent uniformity was more apparent. Veneers and inlay gave way to solid walnut or

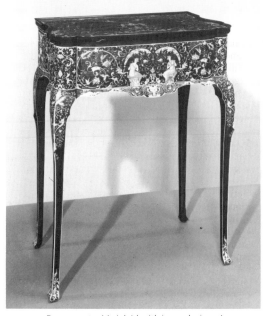

Rosewood table inlaid with ivory, designed
by Philip Webb c. 1880

mahogany, rococo curves were less in evidence, and
carving, while still abundant, was concentrated in more
appropriate places. However unacceptable to present-
day taste the new designs are, it cannot be denied that
the best pieces of furniture made up to about 1867 were
a great improvement on those made in the bad years up
to 1851. French designers were responsible for much of
the improvement. Their influence was felt in the
productions of all the leading London manufacturers as
well as those who made cheaper goods by mass
production methods. Later developments in design

originated outside the trade when artists and architect-designers took over the new trend.

William Morris (1834–96) rebelled against the deadening effects of mass production, of slavery to the machine, debased designs and debased lives. The whole industrial scene, begetter of slums, misery and ignorance, was the dragon that had to be slain. Only Art, said Morris, could give people back their self-respect and create surroundings that could soothe and elevate them. His dream was to exalt Art through peasant communities and hand craftsmanship, and though he realised the impossibility of reorganising the whole of society, and later modified some of his strictures against the machine, his influence on design, painting, pottery and manufacture was far-reaching, both at home and abroad.

In 1861 he founded a company of 'historical artists'. Burne-Jones and Rossetti, the Pre-Raphaelite painters, were among the seven partners. George Jack, an American, was a designer, and Philip Webb (1831–1915) was an active member. Though he was primarily an architect, Webb designed furniture that was both distinctive and practical. The production of carpets, tapestries, wallpapers, tiles, furniture and fabrics was executed by highly skilled craftsmen and designed by artists of exciting imagination and originality. Among the furniture that Morris's firm made were simple cabinets with scenes from medieval romances painted on the panels and cheap, rush-seated country chairs.

Followers of Morris formed little companies who left the towns for the country and used traditional methods of carving, weaving, pottery and metalworking to produce much beautiful work. Among the most important of these groups was the Cotswold School, based at Sapperton, near Cirencester. It was led by William

Lethaby, Sidney and Ernest Barnsley and Ernest Gimson, who became noted for the respect for materials they applied to their country-made furniture. The Art Workers' Guild was founded in 1884 (a distinguished member was C. F. A. Voysey who constructed all his furniture from plain oak), and the Arts and Crafts Exhibition Society came into being in 1888, both groups trying to prove that there was an alternative to the soulless methods of the machine. In Scotland the Glasgow School led the renaissance in the last decade of

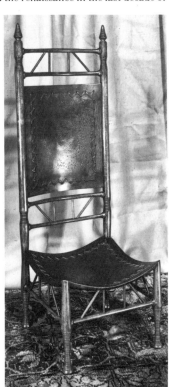

High-backed chair
from Liberty's,
c. 1884

the century. Francis Newbery was its inspiration, and among its designers was Charles Rennie Mackintosh (1868–1928), a noted architect.

But, however far-reaching the influence of all these innovators, they fought a losing battle on the contemporary scene. Their hand-made work was inevitably more expensive than machine-made products, and more difficult to sell in the open market. The furniture factories of the towns gradually displaced the small workshops in country villages, and as power-driven mechanisms for sawing, jointing, dovetailing and sand-papering processes were developed the craftsmen had to turn to fitting the parts already prepared by machinery rather than complete each process by hand.

Much of the factory furniture was well-made but designs lacked distinction. 'Suites' for bedroom, dining-room and drawing-room became the vogue. In the bedroom there would be a wardrobe, washstand, dressing-table, bed, bedside pedestal, chairs and towel-rail, each article embellished with the details of an historic style such as Jacobean, Chippendale, Sheraton or Adam. In the dining-room one would find a huge sideboard, dining-table, overmantel, dinner-wagon, dining chairs and coal scuttle all in period style—Elizabethan, Queen Anne or Sheraton. The details were accurate but the effect was lifeless and incongruous. The sad thing about Victorian furniture designers in general is that they could only look back, derive their inspiration from the past, copy rather than invent. The result was decadence, a ragbag of every kind of ornament derived from every country and every age.

Victorian furniture designers
Charles Robert Ashbee (1863–1942) Architect-designer, influenced by William Morris. He established

his famous Essex House Workshop when he founded the Guild and School of Handicraft in 1888. He experimented in Art Nouveau furniture design, using metal, tooled leather and carving as ornament. He made his greatest impact as a designer of jewellery and plate.

Sidney Barnsley (1865–1926) Furniture designer of the Cotswold School and a partner with Gimson in the firm of Kenton and Company. He was associated with

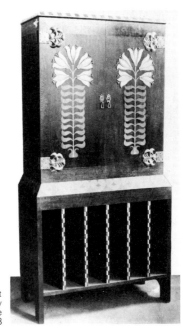

Music cabinet
designed by
C. R. Ashbee
c. 1898

the Arts and Crafts Movement. His early designs were fairly ornate but became simpler when he moved to Sapperton near Cirencester in Gloucestershire in 1893.

William Arthur Smith Benson (1854–1924) A friend of William Morris and one of the founders of the Art Workers' Guild and the Arts and Crafts Exhibition Society. His furniture is usually of rosewood inlaid with other woods. He was an outstanding designer of decorative metalwork.

Ford Madox Brown (1821–1893) Besides being a Pre-Raphaelite painter he also designed furniture in simple and practical styles.

William Burges (1827–1881) His furniture designs were Gothic-inspired. He was influenced by Japanese art and incorporated Japanese forms in his designs. He was responsible for the Medieval Court at the International Exhibition of 1862. Most of his furniture was painted. A sideboard with a panel painted by E. J. Poynter is now in the Victoria and Albert Museum.

Thomas Edward Collcutt (1840-1924) Architect-designer. His work had an emphasis on straight lines, was fanciful and light-hearted and far removed from the fashionable medieval. He worked chiefly in oak.

William Cookes A noted woodcarver of the 1850s, whose best-known work is the 'Kenilworth Buffet', decorated with carvings from Scott's *Kenilworth* and exhibited at the Great Exhibition of 1851.

Astley Paston Cooper (1768–1841) President of the College of Surgeons and Fellow of the Royal Society. He invented the tall-back chair to encourage the proper deportment of young people.

Lewis F. Day (1845–1910) Exhibited at the first Arts and Crafts Exhibition. Most of his work was confined to exhibition pieces. He also designed textiles, wallpaper, glass and clocks.

Christopher Dresser (1834–1904) A noted collector of Japanese art who had a strong influence on good taste. He owned the Art Furniture Alliance with a showroom in New Bond Street, London. His designs are simple and free from extraneous ornament.

Charles Lock Eastlake (1836–1906) Architect-designer, one of the leaders of the Arts and Crafts Movement. His furniture was simple in design and construction and had little ornamentation. His *Hints on Household Taste in Furniture, Upholstery and Other Details* was published in 1868.

Ernest Gimson (1864–1920) A prominent member of the Arts and Crafts Movement and the Arts and Crafts Exhibition Society. He appreciated the natural beauty of wood, preferring to work with oak. His furniture was basically simple, and was inlaid with ebony, bone and mother-of-pearl. He set up a workshop-showroom at Sapperton in the Cotswolds with Sidney and Ernest Barnsley.

Edward Godwin (1833–1886) Architect and stage designer who also designed furniture. His work was inspired by Japanese ideas and his style became known as 'Anglo-Japanese'. He had an interest in simple shapes and modern treatment of well-known styles rather than reproducing old forms, believing that functional design was more important than style. He was a friend of Whistler, who decorated his yellow 'Butterfly Suite' which was shown at the Paris Exhibition of 1878.

Sir Ambrose Heal (1872–1959) A distinguished designer of good-quality fumed oak bedroom furniture. He was a member of the Art Workers' Guild and his early designs were influenced by Morris and Gimson. His family firm, Heal and Sons, of Tottenham Court Road, London, was one of the few firms to be influenced by the Arts and Crafts Movement.

George Jack (1855–1932) Associated with the Arts and Crafts Movement. From 1890 he was chief furniture designer to Morris and Company, the firm originally founded by William Morris in 1861.

Owen Jones (1809–1874) Architect and ornamental designer, and Superintendent of the Works of the Great Exhibition. His *Grammar of Ornament* (1856) had considerable influence on the designs of wallpapers, carpets and furniture.

William Richard Lethaby (1857–1911) A leading figure in the Arts and Crafts Movement and the Arts and Crafts Exhibition Society. He designed chiefly oak furniture, sometimes decorated with marquetry. He became Professor of Design at the Royal College of Art in 1890 and a member of the short-lived firm of Kenton and Company.

J. C. Loudon (1783–1843) Author of the important *An Encyclopaedia of Cottage, Farm and Villa Architecture and Furniture*, first published in 1833.

Charles Rennie Mackintosh (1868–1928) Architect and exponent of Art Nouveau. His work was based in Glasgow. His designs were elegant, sophisticated and beautifully balanced.

Arthur Heygate Mackurdo (1857–1942) Architect and designer of furniture, wallpaper, textiles

Oak writing desk, designed by Arthur Mackurdo c. 1886

and books. He was a friend of Morris and Whistler, a founder-member of the Century Guild in 1882 and one of the creators of the Art Nouveau movement.

William Morris (1834–1896) Craftsman, designer, poet and socialist. He was a close friend of Edward Burne-Jones. Inspired by Ruskin's *Stones of Venice* he

trained as an architect but soon turned to painting and designing furniture. He became the principal founder-member of Morris, Marshall, Faulkner and Company in 1861, and produced wallpapers, simply designed furniture, stained glass, metalwork, etc. The firm survived as Morris and Company from 1875 to 1940. With Rossetti he leased Kelmscott Manor in Gloucestershire in 1871, and Kelmscott House in Hammersmith, London, which gave its name to the Kelmscott Press in 1891. From it were issued some magnificent and much-sought-after books. He founded the Society for the Preservation of Ancient Buildings in 1877, the Art Workers' Guild in 1884, the Socialist League in 1885, and the Arts and Crafts Exhibition Society in 1888.

Morris was much influenced by Ruskin, the Gothic revival and the Pre-Raphaelites and he helped to prepare the ground for Art Nouveau. He opposed the damaging effect of mass production on the contemporary arts and advocated a return to hand-craftsmanship.

Augustus Welby Northwood Pugin (1812–1852) Architect-designer. He was Commissioner of Fine Arts for the Great Exhibition. He encouraged the idea that Gothic furniture in the house was an aid to high ideals and a moral way of life. Style and Christianity were inextricably confused in his mind.

Gerrard Robinson (1834–1891) One of the foremost woodcarvers of his day. He specialised in highly-carved sideboards with pictorial themes. The most famous is his 'Chevy Chase' sideboard which is carved in minute detail with scenes illustrating the medieval border ballad. His 'Robinson Crusoe' sideboard is now in the Victoria and Albert Museum.

John Pollard Seddon (1827–1906) Architect and designer of furniture in the neo-Gothic and medieval

styles, mainly for the family firm. One of his cabinets was painted by Morris, Rossetti and Burne-Jones.

Henry Shaw (1800–1873) Architectural draughtsman and antiquary. His books on ornament influenced furniture designers in the middle of the nineteenth century. His *Encyclopaedia of Ornament* appeared in 1842.

Richard Norman Shaw (1831–1912) Architect and designer, responsible for the Queen Anne style of domestic architecture of the 1870s. He designed art furniture with W. R. Lethaby.

Bruce James Talbert (1838–1881) Architect-designer. His *Gothic Forms Applied to Furniture* appeared in 1867. Later came *Examples of Ancient and Modern Furniture*, and both books were very influential. He was an active member of the Arts and Crafts Movement. His furniture was large, in a simplified neo-Gothic style, with inlaid geometric motifs and low-relief carvings.

Charles Francis Annesley Voysey (1857–1941) A leading designer of Art Nouveau furniture. He combined the traditional with new trends in design and favoured plain oak furniture. He was a member of the Art Workers' Guild and first showed his furniture with the Arts and Crafts Exhibition Society in 1893. His best-known design is the 'swan' chair, which was both comfortable and graceful. The front legs were carved in the shape of a swan's neck, the uprights of the back ending in swans' heads.

Philip Webb (1831–1915) Architect and designer who was responsible for most of the painted furniture produced by Morris and Company, of which firm he was a founder member. He favoured the neo-Gothic

style. The Victoria and Albert Museum has a chest painted by Morris with scenes from the legend of St George, and the Ashmolean Museum in Oxford has one of his wardrobes painted by Burne-Jones with scenes from Chaucer.

Victorian furniture can be seen in the following museums:

Aberystwyth *Ceredigion Museum*
Reconstructed cottage interior of 1850
Barnard Castle (Co. Durham) *Bowes Museum*
Bedford *Cecil Higgins Art Gallery*
Rooms which evoke the atmosphere of a late Victorian home
Bibury (Glos.) *Arlington Mill*
Cheltenham *Art Gallery and Museum*
Victorian kitchen
Chertsey (Surrey) *Museum*
East Cowes (Isle of Wight) *Osborne House*
Queen Victoria's private rooms
Leeds *Abbey House Museum*
Three full-sized streets of nineteenth-century houses, shops and workplaces
London *Carlyle's House, Chelsea*
Dickens House, Doughty Street
Geffrye Museum, Shoreditch
Period homes of the middle classes
Leighton House Art Gallery and Museum, Kensington
Victorian furniture in period rooms
Museum of London, London Wall
Victoria and Albert Museum
Luton *Museum and Art Gallery*
Norwich *Strangers' Hall*
Peterborough *Museum and Art Gallery*
Portsmouth *City Museum and Art Gallery*

Rochdale *Museum*
Rothby (Northumberland) *Cragside (National Trust)*
St Albans (Herts.) *City Museum*
Southport (Merseyside) *Botanic Gardens Museum*
Victorian period room
Sunderland (Tyne and Wear) *Grindon Museum*
Period rooms and shop interiors
Museum and Art Gallery
Period rooms
York *Castle Museum*
Victorian room

GLASS

During the eighteenth century the heavy duties levied on British glass caused glassmakers to ornament their wares with engraving, cutting, gilding and painting to make up for having to use less glass in the making of the article. The duties were also responsible for the introduction of the coloured glass associated with Bristol and Nailsea, a village near Bristol, where a glassworks was established in 1788. As Ireland was excluded from the duty the result was that large firms were started in Dublin, Belfast, Waterford, Cork and Newry. Irish prices were thus much lower than those of English firms, and the Irish industry dominated the scene until 1845.

In that year the tax on flint glass was abolished and English glass manufacturers were able to compete again on equal terms. They returned to the use of flint glass (now called lead crystal because it contains lead oxide as a flux) and began to experiment with Continental ideas. There was a growing popularity for clear glass painted in enamel colours, and this was followed by cased glass (which had two or more layers differing in colour and overlay, the design being cut through to the

body colour). Decanters, wine glasses, vases, toilet water bottles and scent bottles were made extensively in cased glass. Clear glass was covered with up to four layers of coloured glass, all fused together so that the cutter revealed the intervening colours in simple patterns. Rice Harris of Birmingham displayed some elaborate cased glass at the Great Exhibition.

Another and cheaper form of overlay was called flashed glass. The basic glass vessel was allowed to cool and was then dipped into molten coloured glass. The film left on it was cut through to show a pattern in the clear glass. Several coats of different colours could be applied before the glass was reheated and blown into shape.

In the late 1840s there was a great interest in *millefiori* paperweights, and these are now highly regarded by collectors. Each flower consisted of a slice cut from a glass rod that had been built up layer by layer round a central core and then drawn out. Slices from different rods were arranged on a clear glass base and covered with a glass dome that acted as a magnifying glass. The Whitefriars Glassworks in London and George Bacchus and Sons of Birmingham made paperweights in the style of Baccarat, the greatest French producer of fine glass, and Stourbridge too was an area which specialised in paperweights. Stourbridge was also famous for glass novelties such as umbrellas, shoes, urns, buckets, rolling pins and walking-sticks. Nailsea lent its name to a range of glass cottage ware made of dark bottle glass flecked with colour and intended for sale at country fairs and markets. Also from Nailsea came witch balls. Originally they were containers for holy water and were hung from the ceiling, windows or at the doors of cottages as a protection against witches. They were made in a variety

(right)
Bowl of
layered glass,
clear, opaque,
white and ruby

(below)
Paperweight
with closely
set millefiori

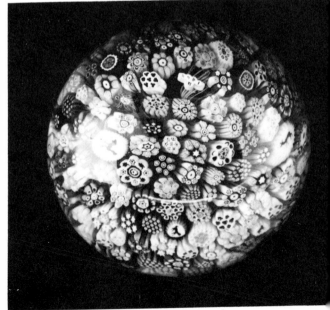

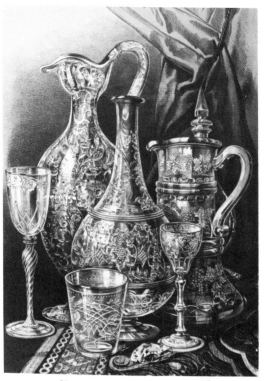

Glass shown at the Great Exhibition

of tints and were decorated. The interior could be coated white and marbled with vivid colours, and a process was developed for applying real silver to the inside of a glass ball.

In 1840 Bohemia was the cut glass centre of Europe, but after the repeal of the Excise Act British glass cutters led the world, though their work became

increasingly elaborate. The glass shown at the Great Exhibition was heavily cut and far too ornate. A monster cut glass fountain made by Osler of Birmingham was a sensation. Admired then, it would now be regarded with horror.

Eventually there was a reaction from what were called barbarous and unnatural techniques and cut glass lost favour in fashionable circles. Surface decorations alone were approved of. During the next 20 years glass cutters turned to delicate wheel engravings. Scenes of rococo and classic fantasy, such as flowers, foliage, ferns and feathers, appeared on decanters, vases, water jugs and carafes. Diamond point drawing was also employed, and etching became popular. Etching is based on the action of hydrofluoric acid on glass. The glass was dipped into melted wax resistant to acid, the design was drawn with a steel-pointed stiletto, and the acid bit in the design by eating into the incised pattern. The first designs were geometrical, but later they became much freer. The method was first developed in England by Henry Richardson of Woodsley in the late 1850s, though it was in use on the Continent much earlier.

In the 1880s cut glass came back into fashion, inspired by the glass of sixteenth-century Venice. Fancy glass of all varieties was widely produced. Some had an acid-induced satin finish. The semi-opaque 'Burmese' glass, first produced from the metallic element uranium in 1855, was heat-shaded from greenish-yellow to deep pink. It was much admired by Queen Victoria, who ordered vases and a tea service from an American glass company. Thomas Webb obtained a licence to manufacture the glass in England. 'End-of-day' glass consisted of opaque marbled glass of a deep purple colour with grey and white veins running through it, which was made from slag drawn off molten steel at the end of the

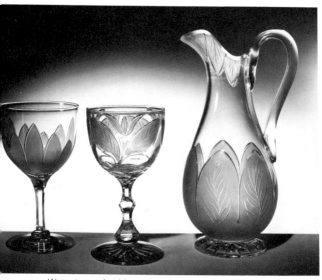

Water jug and goblets with intaglio cut decoration

working day and pressed into baskets, jugs, vases and tableware. This kind of glass is also called marble glass, agate glass, slagware or vitro-porcelain, and it is often mistaken for some kind of china. It was made at Sowerby's Ellison Glassworks in Newcastle upon Tyne and by other firms on Tyneside. Although it was in use from about 1842 it did not become widely popular until the 1870s.

The late Victorians favoured cameo glass in which shallow bas reliefs of portrait heads or classical scenes were carved on a vase of cased or layered glass, and involved the art of hand-tooling, an ancient Roman technique. The most influential English exponent was John Northwood (1836–1902), and he was very successful too with intaglio engraving, where the ornament

79

was hollowed into the glass instead of standing out from the surface. One of Northwood's triumphs in cameo glass was a reproduction of the Portland Vase, commissioned for display at the Paris Exhibition of 1878. It was made by casing a layer of white opaque on to a flint glass body and carving away the opal glass until the design stood out in relief, leaving a white pattern on the dark ground. The reproduction took three years to make and won Northwood a prize of a thousand pounds. George and Thomas Woodall, members of the Northwood 'school', also made some distinguished cameo glass.

Between 1870 and 1880 there was a lot of 'Mary Gregory' glass about. It was an imitation of true cameo, and was the name given to bottles, decanters, jugs and glasses on which white vitreous enamels were used on top of clear or coloured flint glass. The designs showed Victorian children bowling hoops, catching butterflies, picking flowers and indulging in other innocuous pursuits. Mary Gregory was an American enameller who had been inspired by the glass which was imported into America from Bohemia, where the process was first used. Thomas Webb and Sons of Stourbridge was one of the firms who produced Mary Gregory ware in England. A poorer variety of Mary Gregory glass used clear white glass with the faces of the children given flesh tints. The effect was not nearly as fine as the white opaque painting, and as a rival to the real thing it was unsuccessful.

All through the Victorian era glassmakers used various techniques in their experiments with texture and colour, even to the extent of trying to imitate other materials. In 1880 Thomas Webb introduced satin glass, which suggested mother-of-pearl with colours, usually blue, rose, gold and brown, shading off into each other.

The matt effect was achieved by exposing the glass to the vapour of hydrofluoric acid before the decoration was added. Cracking was another effect. One sort of glass was overlain with another, the inner one having a higher degree of expansion than the outer, and when heated a multitude of tiny cracks appeared on the outer surface.

Opaque or semi-opaque glass (achieved by the addition of oxide of tin or bone ash) was much favoured by the mid-Victorians. It was painted with flowers or figures copied from Greek pottery, and was often produced by ladies working at home. Favourite colours were pale and deep blue, pink, green and a light turquoise. Opaque glass is often called Bristol glass, but though an enamelled opaque white glass resembling porcelain was made in Bristol in the eighteenth century, the later and cheaper examples were made at Stourbridge and other glass centres. Bristol glass is, in fact, a generic name for coloured glassware produced in England in the eighteenth and nineteenth centuries and covers every kind of useful and ornamental object.

Opaline glass looks as though it was covered by milk and water and has a frosty shine. Much of it was imported from France in the nineteenth century. That too was painted and gilded, and was a favourite glass for table ornaments, prism vases and lustres. Vaseline glass, known also as 'yellow opaline', was a clear glass, greenish-yellow in colour, with a fiery glow at the edges, and was used for decanters and vases.

During the last two decades of the nineteenth century British glassmakers were strongly influenced by Venetian glass. Their enthusiasm was kindled both by the ideas of mid-century design reformers and by the imported products of the revived Venetian industry. The firm of Powell at their Whitefriars factory in

London produced styles that relied on the beauty of blown shapes rather than deep carving. Philip Webb, an associate of William Morris, was an early advocate of the new styles, which eventually became the English contribution to the relatively short-lived Art Nouveau which played an important part in preparing the ground for glass design in the twentieth century.

Victorian glass can be seen at the following museums:

Dudley *Museum and Art Gallery*
London *Victoria and Albert Museum*
Newcastle upon Tyne *Laing Art Gallery and Museum*
St Helens (Lancs.) *Pilkington Glass Museum*
Stourbridge (Worcs.) *Stourbridge Borough Glass Collection*
Rich in John Northwood glass
Sunderland *Museum and Art Gallery*
Warrington (Lancs.) *Municipal Museum and Art Gallery*

SILVER

Middle-class Victorians were extremely conscious of their position in society, and demonstrated their concern by acquiring expensive and ornate objects, such as large quantities of elaborate silver articles. Apart from being a status symbol, silver could always be depended on to keep its monetary value, and thus was an insurance against the time when a business might fail or the death of the head of the household bring financial chaos. Some of the favourite examples of prestige silver were exhibition items, sporting trophies, wine coolers and tureens, vases, urns, candelabra and massive centre-pieces with sculptured ornament of human or animal

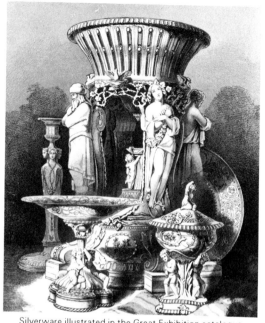

Silverware illustrated in the Great Exhibition catalogue

figures writhing in unlikely positions. Such pieces had no real purpose but to advertise wealth, and they were often singularly ugly.

As a whole, Victorian silver was heavily over-decorated, and mass-production techniques were necessary in order to produce the quantity of items needed for the silver-hungry public. The individuality of the craftsman had perforce to give way to standardisation and repetitive designs. The quality of silverware fell to its lowest level after the Great Exhibition, and some decades were to pass before there was a return to taste and character.

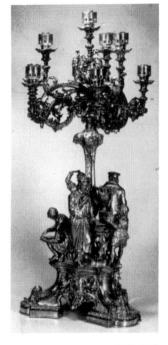

(right)
Silver candelabrum made in 1853 by Hunt and Roskell, showing Michelangelo with his master, Domenico Ghirlandaio, while Lorenzo de Medici examines objects handed to him by a page

(below)
Tea and coffee service, silver with engraved classical decoration

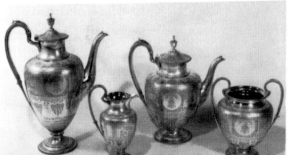

Early Victorians preferred the rococo style of eighteenth-century France, and surviving plain Queen Anne silver was even redecorated with rococo moulding hammered on to it. Second in popularity was the Elizabethan style, on which the decoration matched the carving of the furniture of the period. The third style, Gothic, was used chiefly for church vessels. Arabesque decorations were also popular.

When the inevitable reaction against excessive ornament came in, the rococo and the naturalistic gave way to the classical and the Renaissance. Cast relief ornament was superseded by engraved or chased decoration, and silver articles began to look more like what they were intended to be. Restraint and elegance, though advocated by leaders of fashion, were not wholly approved of by the middle classes, ever slow to change, and they still insisted on natural-looking fruit sprouting from fruit spoons and grapes and vine leaves climbing all over the outsides of wine jugs. Other objects were decorated with high-relief flowers, birds and insects.

Renaissance style silverware consisted of copies of original articles or standard shapes with Renaissance motifs. There was little originality and, though beautiful, the effect was soulless. In the 1870s there was a mixed Adam and Regency revival, and this was followed by a Queen Anne style, both lasting until the end of the century. During those 30 years there were many copies and adaptations of eighteenth-century shapes. Georgian silverware was often copied, so slavishly, in fact, that only the hallmark distinguished it from the original. Items from that period which have an interest in their own right are those which differ from the originals, either in decoration or proportions.

Genuine hand-made articles of original design were made when the Arts and Crafts Movement became

influential with a small circle of forward-looking silversmiths. It brought a new impetus to their craft, even though their appeal was to a minority. Christopher Dresser (1834–1904) was one of the forerunners of modern design. His work was plain and functional and had a marked Japanese influence. There was also C. R. Ashbee (1863–1942), whose designs were made up by his Guild of Handicrafts. He understood the natural quality of the material and related it to the form chosen for the object, insisting that useful things should be made well and made to be beautiful. In 1899 Liberty's began to market the 'Cymric' range of silverware, which was influenced by Ashbee's designs.

At the beginning of the twentieth century it was possible to find the straightforward, no-nonsense silver and the quietly elegant, though for ordinary domestic use silverware continued to follow modifications of historic styles. There are now signs of a move away

Silver inkstand

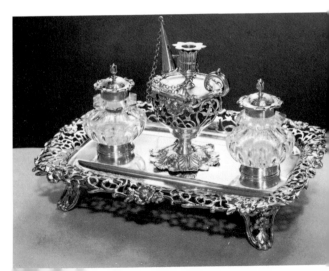

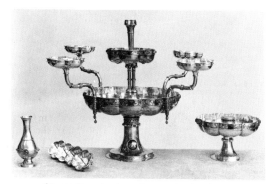

Silver-gilt centrepiece, dessert stand and cruet,
designed by William Burges, 1880

from modern simplicity. Many collectors are becoming
attracted to the style and quality of early Victorian
ware, which is easier to find and not nearly as expensive
as the earlier Georgian.

Silversmiths have always been rigidly controlled in
the quality of the metal they use. Hallmarking was
instituted in 1300 when all wares of silver and gold
were obliged to bear a leopard's head, which was the
mark of King Edward I. Nowadays the following marks
are required: the standard mark, which shows the
standard of the metal; the office mark, showing which
assay office hallmarked the ware; the date mark,
showing the year in which the article was hallmarked
(the letter and design are changed in cycles); and the
maker's mark, which consists of the initial letters of the
maker's name or style of trading. From 1784 to 1890
the sovereign's head was added to indicate duty paid. In
1977 a special additional mark was struck on all British-
made silver over 15 g in weight—the Queen's head in

profile, to celebrate her Silver Jubilee. Misleading marks are often found on Victorian Sheffield plate and electroplate, applied by unscrupulous manufacturers who hoped to pass off their wares as wrought silver.

The invention of Sheffield plate in 1743 led to the first use of a substitute for silver. Thomas Boulsover, a Sheffield cutler, fused a thin sheet of silver to a thicker sheet of copper alloy, first on one side, then on both, and the sheet could then be shaped by most of the methods used for silver. Boulsover and his partner started with silver-plated buttons, then went on to small boxes. Then Joseph Hancock, a business competitor, entered the field of the silversmith and produced tea and coffee pots, saucepans and candlesticks. Later the firm of Tudor and Leader made dishes, candelabra, salvers and tureens of high artistic and technical standards. John Flaxman and the Adams brothers were among the artists who designed for them.

The process of silver-plating was further developed by Anthony Merry in 1836, when he plated the silver direct to a foundation metal of German silver, which was a mixture of nickel, copper and zinc. Sheffield plate was not hallmarked, though between 1784 and 1836 many manufacturers, working within a hundred miles of Sheffield, were allowed to add their own mark to their products. Beautiful tableware was no longer the prerogative of the rich. Families of moderate means were able to grace their tables and sideboards with silver-plated articles of elegance and fashion. The effect of the popularity of Sheffield plate was so detrimental to the silversmith's craft that for half a century little wrought silver was made in England, a situation that remained until the 1840s.

In 1840 electro-plating was invented. This process, by which a base metal was covered by a thin coating of

silver applied by electrolysis, also led to cheaper articles which looked like silver and which could be produced quickly. The patent was bought by the firm of Elkington, Mason and Company of Birmingham. The mass market for silver objects was revolutionised by the new process, and Sheffield plate was ousted so quickly that by the 1850s no firm in Sheffield was producing it. The technique of electro-plating meant that the base metal articles could be mechanically die-stamped out of copper sheeting and need not be hand-wrought or cast, and consequently the art of the craftsman suffered a sad decline.

Examples of Victorian silver may be seen at:

London *Victoria and Albert Museum*
Plymouth *City Museum and Art Gallery*
Sheffield *City Museum and Art Gallery*

Electro-plated double dish, c. 1880

JEWELLERY

Victorian jewellery is probably the most accessible of all antiques and is found in profusion in antique shops and on market stalls, still at relatively modest prices. The best items were, of course, designed by superb craftsmen and are beyond the reach of most collectors, but much of it was mass produced, particularly in Birmingham, which became the centre for cheap ornaments. Styles changed so much during the nineteenth century that the variety is enormous, and the collector has a wide field to explore. Several styles continued right through the era and it is sometimes impossible to date an item to within at least 20 years. Manufacturers generally showed such enthusiasm for experiment and variety that its overall character is difficult to define. Eclecticism was as much in evidence in jewellery design as it was in painting. Inspiration was drawn not only from previous fashions but also from historical sources from all parts of the world. Romanesque, Gothic and Renaissance styles formed the main sources, but Italian and North African designs, copied from objects shown at international exhibitions, were common, and archaeological excavations gave rise to Egyptian, Assyrian, Greek and Asiatic forms.

However, all these influences were eclipsed by a fondness for the naturalistic, with birds, flowers and butterflies modelled in precious stones. Gold-set tiaras with coral berries, diamond roses, garnets and seed pearl grapes and gold and enamel leaves are typical examples. Jet, coral and amber were used increasingly, and cut steel also had its vogue.

Until the 1860s sets of jewellery were much worn. A set would consist of a matching necklace, brooches, earrings, bracelet and pendant. Pearls were immensely popular. Claw settings were used to show off fine gems.

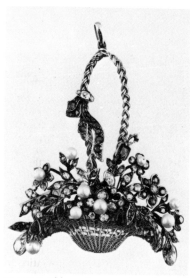

Gold pendant
set with
diamonds,
sapphires
and pearls

15 carat gold was in general use for settings, though for items of the highest quality 22 carat gold was preferred. When styles in hair and dress changed, the fashions in jewellery changed too. If the hair was worn low over the ears then earrings were out, and necklaces were little in evidence when dresses had a high neckline. For evening wear, when necklines were low, fashionable ladies glittered from the shoulders upward with diamond and pearl ornaments of every description. In 1886 a certain Lady Carew once wore ten different diamond brooches round her low neckline, thus revealing her wealth rather than her taste. When hair was worn high and the ears were exposed, long drop earrings and jewelled hairpins were seen. In the 1880s the Princess of Wales popularised the diamond dog collar. Large pieces of head jewellery were produced to balance the enormous crinolines worn in mid-century, but when

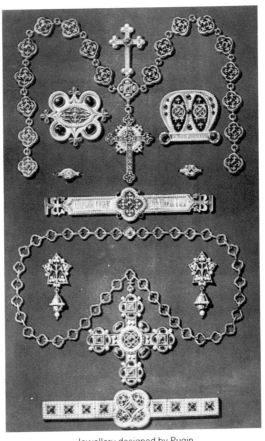

Jewellery designed by Pugin

women wanted to look more ethereal they took to pale and delicate decorations.

As the century advanced jewellery became very showy. In the 1860s and 1870s there was a passion for Renaissance designs. Two famous Italian jewellers, Castellani and Giuliano, produced some outstandingly beautiful examples of their craft and set the fashion for bold and elaborate pieces. They set clusters of gems and large pearls in brooches and pendants in heavy gold surrounds, but after 20 years or so heavy settings went out and the quality of stones was considered more important than the ornateness of the setting, and very thin gold frames took their place.

Art Nouveau jewellery appeared in the last years of the Victorian era. The *avant garde* designers became obsessed with the new phenomenon of Japanese art and artefacts, especially by Japanese colours which fused gently and smoothly in a natural-looking way and which were translucent, as if a stone had an inner life of its own. Floral designs for jewels featured everyday plants and flowers, especially those with coiling tendrils and pointed petals. Wasps, ants, snakes and lizards were often part of the designs. Such new ideas in design unsettled the conventional, brought up on roses and lilies, and Art Nouveau was only popular among those brave souls who dared to ignore the leaders of society.

In France the new designers were led by René Lalique, who provided Sarah Bernhardt with the jewels she wore on stage. His designs were dramatic, sensuous and curiously sinister. In England there was more emphasis on linear quality than on the decadent and erotic. C. R. Ashbee was the most celebrated designer of his time. He concentrated on abstract designs in gold and silver; the gems he used were of secondary importance and included moonstones, rose quartz,

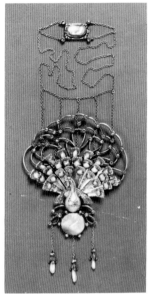

Silver pendant with pearls designed by C. R. Ashbee

(opposite page)
Necklaces and earrings: pearls *(above)* and amethysts *(below)*

blister pearls and turquoises. Arthur Liberty, not a designer but a shopkeeper, was the most influential member of the Art Nouveau movement with his 'Cymric' range of jewellery. He employed brilliant designers, among them Arthur Gaskin, Jessie King and Oliver Baker, also a group of distinguished women, and sold their products in his Regent Street shop. Liberty's designers used both cheap and expensive stones, ivory, horn, and silver rather than gold. Moonstones and blister pearls superseded sapphires and rubies, and opals were among the favourite stones. Amber was also predominant. Materials were considered for their decorative rather than for their intrinsic value.

In America Louis Tiffany introduced Art Nouveau to the discerning rich, and in Europe Fabergé captivated

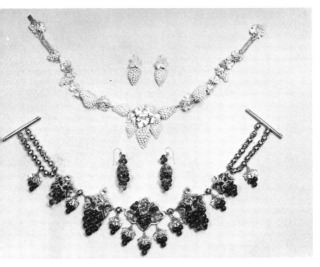

the Czar and Czarina of Russia with his exquisitely jewelled cigarette cases, miniature animals, flowers and, above all, his Easter eggs made of chalcedony set with rubies, beryls alight with diamonds and agates set with sapphires. His range was vast and he influenced all the finest jewellers of his age.

Of course all was not tiaras and diamond dog collars in the jewellery world. Women who could not afford pearls and sapphires had to make do with semi-precious stones and paste jewellery, which was made out of glass paste containing lead oxide. Whitby jet was imitated by black glass called 'French jet'. Coral, imported from Italy, was widely used, especially for necklaces, many of which were given to babies as christening presents. Cairngorm and pebble jewellery were also popular among the less affluent. Cairngorm is a quartz of smoky colouring streaked with brown, red and yellow markings and is found in the Scottish mountains. Queen

Victoria's acquisition of Balmoral Castle did much to stimulate an interest in all things Scottish, and brooches were even made from the claws of grouse and ptarmigan.

Lava from Pompeii was carved with classical figures to resemble the more costly cameos and medallions. Seed pearls were popular with all classes. They were set round a single large pearl in rings and brooches or made into flower clusters. Hair ornaments set with seed pearls were much worn, usually as twisted ropes which were entwined among ladies' tresses, and jewelled combs in the Spanish style or sprays of flowers made of gold or enamel were other hair adornments. Snake bracelets and rings with enamelled scales and jewelled eyes made their appearance in late Victorian times.

Men, no longer the peacocks of Regency times but sober-suited worthies of business and the professions, preferred to let their wealth shine forth on their wives and daughters. They contented themselves with thick-linked gold watch chains, cravat pins of semi-precious stones heavily mounted in gold, and amethysts set in gold on their fingers.

Mourning jewellery was almost an industry by itself. Rings, brooches, earrings and necklaces of carved jet mounted in gold were the most common items, and many people in mourning wore rings in which plaited or coiled hair taken from the departed relative was incorporated.

Ivory and jade were always greatly admired. The former was made into brooches, lockets and necklaces which looked like ropes of flowers. Jade was both costly and rare. It came principally from China and was first acquired by rich women travellers or those who had lived in the East.

Piqué jewellery was a curiosity of the time, though it was a short-lived craze. The background material was

WOVEN IN SILK BY THOMAS STEVENS, INVENTOR AND MANUFACTURER, COVENTRY AND LONDON, (REGISTERED.)

The First Train.

1 Stevengraph

2 'Awfully Jolly' – Music cover by Alfred Concanen

3 William de Morgan tiles

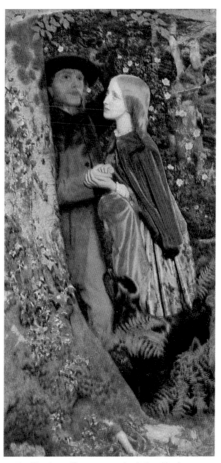

4 *The Long Engagement* by Arthur Hughes

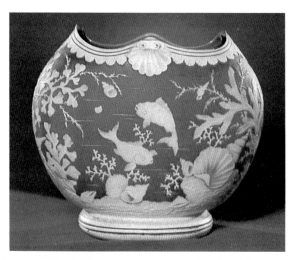

5 *(above)*
Cameo vase

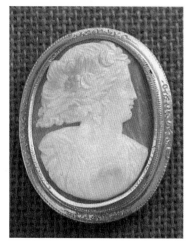

6 *(left)*
Cameo brooch
*Courtesy Victoria
& Albert Museum*

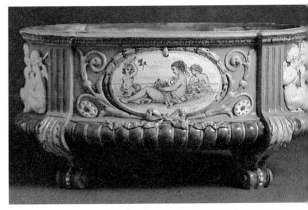

7 *(above)*
Queen's ware jardinière

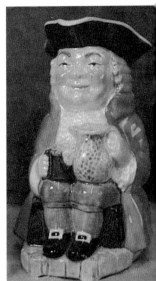

8 *(right)*
Toby jug

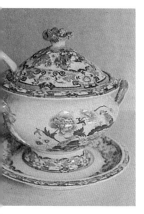

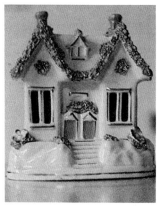

9 *(above left)*
Tureen

10 *(above right)*
Pastille burner

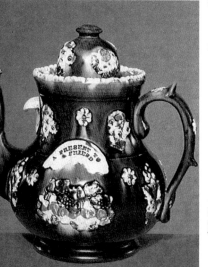

11 *(left)*
Barge ware teapot
*Courtesy Victoria
& Albert Museum*

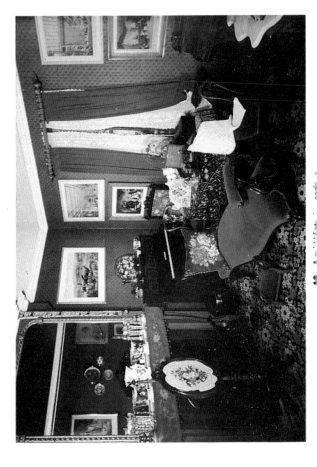

tortoiseshell, or occasionally ivory. It was heated, cut and shaped into crosses, pendants, brooches and earrings, the surface dotted with a design, then a drill worked minute holes in the surface following the pattern. Then tiny rods of gold or silver were inserted into the hot shell. The craft was a sixteenth-century one but, apart from a brief revival in the early nineteenth century, it was not until machines could perform the intricate operations in the 1870s that *piqué* jewellery was produced in any quantity.

It is clear that Victorian jewellery comprises so many scores of items, the fruit of so many styles and fashion changes, both costly and cheap, beautiful and ugly, that the collector can only be confused and bewildered when trying to decide what to concentrate on. The rare and valuable items have found their way to expensive antique shops, auction rooms and museums, but there are still many fascinating objects around that can form the basis of attractive collections. Semi-precious stones, sporting brooches and pins, chains that were attached to lorgnettes, muffs and chatelaines, charms, folk jewellery, hair and mourning jewellery, hat pins, cloak clasps, animal brooches, belt buckles—the choice is almost endless and a thin purse need be no deterrent.

The finest and most varied collection of Victorian jewellery can be found at the Victoria and Albert Museum in London and there is a collection of jet jewellery at the Castle Museum, York.

PORCELAIN AND POTTERY
Porcelain

Porcelain is a generic term for different types of ceramics which are characterised by a white or near white body, a quality of translucency, and a vitrified, therefore non-

porous, body. True or hard paste porcelain is made from a white-burning clay known as kaolin or china clay and a kind of feldspar, and is given a high temperature firing. The plastic material which emerges from the kiln is then shaped by the usual potting methods. When unglazed it is called biscuit porcelain. Powdered feldspar is the glaze normally used and distributed over the surface before firing. In the nineteenth century under-glaze colours were fired at the same time as the body and glaze, or enamels (vitreous compositions coloured by metallic oxides) were fired on afterwards at a lower temperature. Hard paste is resistant to great heat and most acids. The first English factory to make hard paste porcelain was founded by William Cookworthy, a Plymouth chemist, in 1768.

Artificial or soft paste porcelain is given a lower temperature firing. The clay is mixed with powdered glass, or the ingredients of glass, instead of feldspar, and is glazed at a second firing with a lead glaze which lends itself to enamel painting of fine quality. Soft paste porcelain was little made in the nineteenth century. Though excellent for decoration it was liable to crack when heated.

Bone porcelain, or bone china, is a modification of hard paste porcelain, made with the addition of ground and calcined ox bones. It was first produced about 1800. It is fired at a slightly lower temperature than the hard variety and combines the advantages of both hard and soft types.

Soapstone porcelain was not much made after the beginning of the century. Feldspar was replaced by soapstone or steatite; the advantage being that the ware could bear boiling water without cracking.

Parian ware was a biscuit or unglazed porcelain with a waxy surface resembling marble. It was developed in

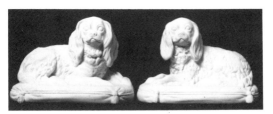

Recumbent dogs in white Parian ware

England in 1845 and was used for portrait busts and replicas of sculptures.

Semi-porcelain, also known as ironstone china, opaque china or stone china, is a type of hard paste porcelain which became popular, because of its durability, for making the crockery used by hotels and restaurants, and was widely manufactured in both England and America.

In porcelain, as in so many fields, the Victorians went back for their ideas to the eighteenth century and fell into the trap of copying the kind of wares that had been produced by Sèvres, Dresden and Chelsea, sometimes so perfectly that even experts were confounded, but such accuracy was depressing in its lack of originality. At the beginning of the century the principal factory was Worcester with its wares of classical shape decorated with topographical paintings. This early period was dominated by a revived rococo style, and vases were decorated with elaborate moulding and bouquets of flowers, often emphasised by brassy gilding. There was such a lack of flat surfaces, particularly in things produced at the Coalport factory, that painted decoration was restricted, except for domestic ware. By the 1850s most of the important manufacturers were decorating their products in the Sèvres style. Floral

designs were the most popular; figure subjects were less common.

During the next 20 years, however, a reaction against Sèvres set in and a more naturalistic movement took its place; birds and flowers became the favoured objects. Greek and Renaissance styles succeeded rococo, with Cellini-type ewers much in evidence.

Decoration consisted chiefly of painting and gilding until the mid-1860s; then potters began to concentrate more on how to treat the surface of their pots. 'Jewelled' ware and pierced ware became popular, and the firm of Minton specialised in *pâte-sur-pâte* technique. This was developed by Marc-Louis Solon who worked for Minton's in the 1880s. He achieved a cameo-like effect by applying thin washes of creamy slip instead of pigment over an unfired dark-tinted paste of vase or plaque, building up the subject in very low relief. It was a slow

(left) Sèvres-style 'Four Seasons' vase
(right) Pâte-sur-pâte flask

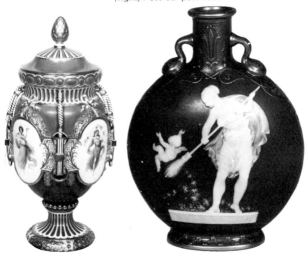

process; one vase took seven months to complete. The result of giving the texture of a pot preference over the decoration was a decline in the quality of the painting. Some of it was mawkish, even badly drawn, and landscapes became insipid and unrealistic. Figure subjects included pseudo-classical Cupids, ladies in Greek costume and also sometimes in contemporary fashions.

The *Belleek* pottery, established in Ireland in 1857, was the result of the discovery of high-quality feldspar in County Fermanagh. It was far superior to any found in England and Staffordshire potters imported great quantities. Belleek ware was highly successful. It had an iridescent lustre like mother-of-pearl on a beautiful thin white porcelain. Only the best artists and potters were employed, and they produced costly dessert services and fine tableware based on shells and other marine objects, exquisitely painted, gilded and enamelled. Natural flower shapes were used a great deal. Flowers in full relief trailed over baskets and covered bowls of delicate lattice work. Small leaves of shamrock and tiny flowers such as lily of the valley were specially favoured. The Belleek factory also made parian statuary, plant pot holders and ordinary tableware.

The *Coalport* factory at Coalbrookdale in Shropshire was founded by John Rose about 1790 and was one of the most successful of English ceramic firms. In 1814 Rose bought the Caughley factory in Shropshire, where the first 'willow pattern' design was used, and moved the equipment and the workers to Coalport. He later acquired the moulds from the South Wales factories at Nantgarw and Swansea. Coalport designs became increasingly extravagant. The favourite ground colour was a beautiful pink called Rose Pompadour, and panels were embellished with rioting flowers, fruit and birds. The firm produced such brilliantly executed copies of

old Sèvres, Meissen and Chelsea porcelain, especially vases, that even the experts were fooled when they were shown at the Great Exhibition.

The firm of *Copeland* came into being in 1833 when the original Spode factory, established by Josiah Spode in Stoke-on-Trent in 1770, was bought by William Taylor Copeland. Spode had made the first type of English bone china and Spode ware was famous for its willow pattern. Under Copeland both porcelain and pottery were produced. A feature of his vases and dinner services was the decoration using exotic birds. Copeland specialised in rich ground colours, highly modelled forms and lavish gilding, and his products generally were fussy and over-elaborate. There were some very flamboyant examples on show at the Great Exhibition. In the 1850s Copeland's introduced 'jewelled' porcelain. The decoration was produced by applying coloured enamels on gold foil fused to the porcelain by firing. The firm also made table services for dolls' houses. Its most significant achievement, though, was the development of the parian process, the brain-child of Thomas Battam, the art director, in 1845.

Davenport ware was made by John Davenport at his pottery at Longport in Staffordshire from 1793 to 1830, and after that by his sons, up to 1882. They made bone china and other quality wares, and their products were deservedly in great demand. Among their customers were members of the aristocracy and royalty. The favourite ground colours were apple green and Rose Pompadour, and fruit, flowers and birds were brilliantly enamelled. To modern tastes there was an excessive use of gilding. In their last years the Davenports made a strong feature of Japanese patterns.

Derby porcelain came from a great factory which produced some of the finest work in Europe. Founded

in 1756 by William Duesbury, who bought the Chelsea factory in 1770 and the Bow factory in 1776, the firm flourished until 1811, when business fell away owing to foreign competition. Many of its products of the period were repetitions of eighteenth-century models and styles painted in thick dark colours, including the new colour, maroon. Figures, groups, busts and decorative vases were made in large quantities. Raised gilding was a feature of the work. The pattern or design was built up by painting in a paste made from enamel powder. The object was put into the enamelling kiln and then the hardened raised design was gilded over.

Changes in ownership led to a decline in both production and quality and the factory was forced to close in 1848. The present Royal Crown Derby Company was formed in 1875 by Edward Phillips and William Litherland, who had been associated with the Royal Worcester Company. The use of the Royal Arms was granted in 1890. Its characteristic Japanese Imari pattern, often based on brocades and using rich red and velvety blue colouring, was much sought after by gypsies.

Doulton ware came from Vauxhall about 1818, later from Lambeth. The firm was founded by John Doulton and specialised in brown salt-glazed stoneware, a somewhat crude and heavy product, up till about 1870, making such utilitarian things as flasks, jugs, kitchen ware, drainpipes and sanitary fittings. Then, when Henry Doulton had taken over the business, they went over to art pottery. In 1884 they began to make porcelain, which from 1902 was known as 'Royal Doulton'. One of their specialities was 'Holbein' ware—portraits executed in contrasted inlaid clays; another was 'Rembrandt' ware, which was decorated in relief, often with animal figures. Their 'Lambeth faience' was

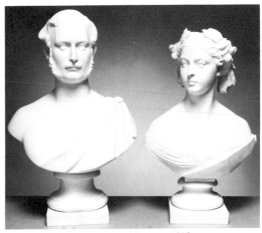

Parian ware, Minton c. 1860

a fine white stoneware decorated with underglaze painting, and 'Chiné' ware was given a novel surface by pressing lace and coarse textiles into the raw clay.

The *Goss* factory was founded by William H. Goss, who originally worked for Copeland, in Stoke-on-Trent in 1858. It is best known for the cheap crested china made for the souvenir trade, but also made small ornaments in parian ware, noted for their pearly lustre and resembling Belleek porcelain.

The firm of *Minton* was established in 1790 by Thomas Minton and his associates and is still one of the foremost ceramic manufacturers. Only highly skilled artists, many from the Continent, were employed to decorate their ware. The business was at first mainly concerned with blue printed earthenware and bone

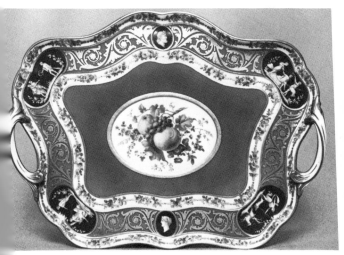

(above)
Minton tray

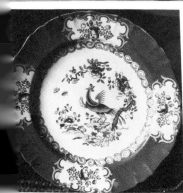

(left)
Minton plate

china. When parian ware was invented it was successfully taken up by Minton and the factory achieved a great reputation. The firm began to specialise in dinner and dessert services, the pieces painted in enamel colours of fine quality with rich borders, and the tureens, dessert baskets and centrepieces were elaborately moulded. In 1850 Prince Albert designed a dinner service for them. Among other distinguished designers were A. W. N. Pugin, Alfred Stevens and Walter Crane.

During the second half of the century tableware and ornaments were made in the Sèvres style. Minton porcelain had a white, more translucent body than any other porcelain of the period. Majolica, parian ware and copies of Sèvres, Della Robbia and Palissy originals were among many brilliantly conceived products. One of the firm's greatest achievements was the *pâte-sur-pâte* method of decoration.

The *Rockingham* factory was first established about 1750 at Swinton in Yorkshire, and at the beginning of

Rockingham teapot

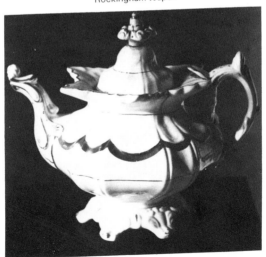

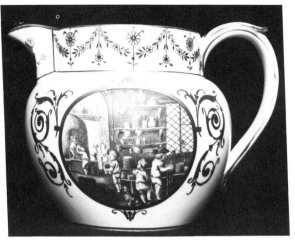

Wedgwood jug: Children as potters

the nineteenth century was connected with the Leeds Pottery. After 1813 the three sons of William Brameld, under the patronage of Earl Fitzwilliam, made earthenware of all kinds, but especially wares covered with a thick purplish-brown lead glaze, coloured with manganese oxide. Lovely tea services were made, too, in ground colours of green, buff and grey, gilded and decorated with flowers and landscapes.

The Brameld brothers unfortunately indulged in costly and extravagant projects: one dinner service cost William IV £5,000 and still proved unprofitable. The works closed in 1842, but Rockingham porcelain continued to be made in London. The ware was skilfully executed, colourful and richly gilded, but the designs were too fanciful and elaborate.

Wedgwood is the most famous name in pottery. The firm was founded by Josiah Wedgwood (1730–95) in Burslem in 1759, and its first and most successful

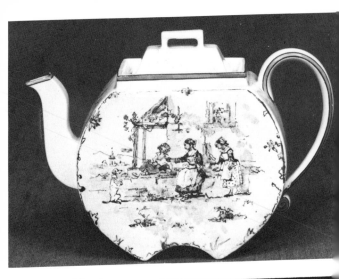

(above)
Queen's ware
teapot
c. 1870

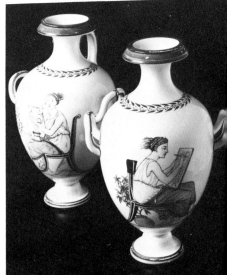

(right)
Queen's ware
vases
decorated
by Walter
Crane

speciality was jasper ware, first produced in 1777 and still being made. It is a fine stoneware which does not require glazing; in many pieces the body is coloured all through. It was produced in a range of colours—soft blue, black, two shades of green, yellow and lilac. It was imitated by other potters though none of them quite reached the Wedgwood standard.

Wedgwood's made other things too: lustreware, transfer-printed tiles, black basalt, parian ware, pearl-ware and a cream-coloured earthenware called Queen's ware. Their bone china was reintroduced in 1878 and became one of their best-selling products. Commemorative ware began in the early 1880s. Wedgwood's have always been in the forefront in experimenting with new processes.

The *Worcester* pottery was founded by a Dr Wall in 1751 and is still flourishing. At the beginning of the nineteenth century Wall made wares of classical shape decorated with topographical painting, and until 1820 Worcester porcelain was made with soapstone instead of feldspar. After 1840 some magnificent ornaments

Royal Worcester candlesticks, modelled by James Hadley

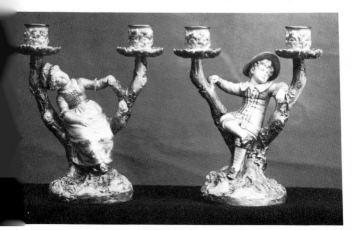

and table services were produced, with first-class artists responsible for the patterns of painted feathers or scales resembling fish skin. Copies of Dresden porcelain and china were also made, and attractive animal figures in white and gold on pale blue bases. One of the firm's most famous productions was the Shakespeare dessert service. It was based on *A Midsummer Night's Dream*, the figures modelled by W. H. Kirk and painted by Thomas Bott. It was exhibited in Dublin in 1853.

As the years went on the firm underwent many changes of ownership, and in 1862 the present Royal Worcester Porcelain Company was established, employing more than 600 people. In the 1870s there was a strong Japanese influence on their work and ivory-toned porcelain bodies were softly glazed and decorated in gold and bronze.

Pottery

The term pottery is usually applied to ceramics other than porcelain; that is, lightly fired earthenware and other opaque wares, as opposed to translucent wares. Porousness resulting from kiln-firing makes glazing necessary. During the nineteenth century pottery exhibited much more vitality and originality than porcelain; it was simpler to make and less costly. Though often crude and garish it had strength and a straightforward charm. The pottery industry flourished all through the century, but up to about 1830 the basic commodity was a cream-coloured earthenware that came in many varieties. Enamelling and printing were the chief methods of decoration; the quality of hand-painting had declined since the previous century. Printing was more in keeping with the spirit of the age, the demand for more and more items, and the move towards mass production. Underglaze blue printing was the most

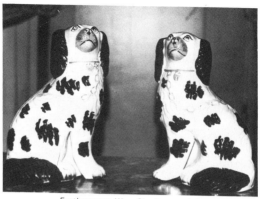

Earthenware King Charles spaniels

widespread decorative technique, though overglaze printing in brown and black was also used.

Victorian pottery can be divided into three broad categories: folk art, commercial mass production and art pottery. The folk art tradition was dominated by the flatback figure. These press-moulded figures or groups, boldly and simply decorated, had a flat undecorated back and were very popular as chimney mantelpiece ornaments. Design and manufacture were simple, and such figures cost little; often they were produced by child labour. By the 1870s their popularity had waned though they were still being made in the early years of this century. Also in the folk tradition were the earthenware cottage-shaped pastille burners and the Maltese terriers and King Charles spaniels, the larger ones being used as door porters. Many Victorian potteries produced various breeds of pottery dogs, less crude than the cheap fairings. There were also toby jugs, cow jugs, fox-mask stirrup cups and thistle-shaped loving cups. Souvenir mugs were made in large quantities. The quality of the latter left a lot to be desired. The colouring was over-bright and the gilding

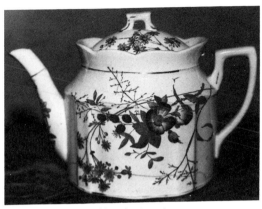

Victorian teapot

too heavy, but as period pieces they are very interesting, particularly the earlier and more restrained examples. Commemorative mugs were often very beautiful. The decorative subjects included black transfer-printed nautical scenes with plaques containing sentimental verses or religious texts. Sunderland ware, a term applied to pink or mauve lustreware, is particularly pleasing.

Mass-produced pottery consisted chiefly of table services, and because millions of pieces in thousands of patterns were made over the years the collector has a happy hunting ground to wander through. For the first 30 or so years of the century everything was decorated in blue because that was the only colour that could withstand the heat necessary to fuse the covering glaze. Topographical scenes had been popular but they gave way to romantic subjects, with leaf and scroll work borders. Floral patterns, too, were common, but an

Majolica plate with green centre and pierced border,
c. 1880

excessive use of gilt spoils the effect for modern taste. In
the 1860s birds, flowers, fruit, fish and game were
fashionable. Sometimes a single bird, flower or fish was
painted on the plate and the name of the variety was
inscribed on the border. Japanese motifs took over in
the 1870s and 1880s, though by comparison with
former designs they were rather insipid. Common
earthenware cooking pots and dishes were little re-
garded by the Victorians. Most were plain, though
Wedgwood made some dishes in fine stoneware that
were decorated with moulded designs and were beau-
tiful as well as functional.

Art pottery was dominated by terracotta, a durable pottery produced by hard baking. It was used for vases, statuary and garden ornaments, and also for mouldings set into the brickwork of houses. Terracotta could be glazed or unglazed, and the commonest colour was a brownish-red. Another type of earthenware, coated with a semi-translucent coloured glaze, was majolica, which imitated the Italian maiolica. Minton's was the specialist firm and displayed some excellent examples at the Great Exhibition. Leon Arnoux, Minton's art

Ewer and plateau of enamelled earthenware,
imitation majolica, Minton c. 1862

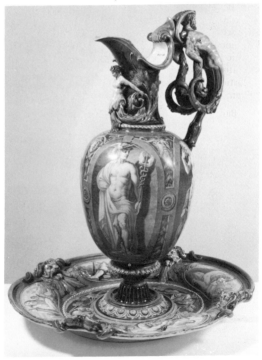

director from 1849 to 1892, developed the coloured glazes of majolica and the lively moulding. The simplest items, vegetable dishes, fruit stands and candlesticks, were green-glazed with a relief pattern, usually of leaves.

Salt-glazed stoneware art pottery was developed by Doulton's in the early 1870s. The glaze was produced by throwing quantities of salt through the top of the kiln when the maximum heat had been reached. Up till then only cooking pots, ginger beer bottles and flasks had been made in stoneware, not only by Doulton's but also by many minor Staffordshire potters, and the introduction of brown and blue beaded and decorated pots which did not pretend to be other than what they were was a welcome change to people who were tired of imitation and pretence. Doulton's employed talented ceramic artists from the Lambeth School of Art to decorate their distinctive art pottery.

Martinware, produced by the four Martin brothers at Fulham from 1873 to 1914, was an assortment of

Bird and fish-shaped jug in salt-glazed stoneware, Martin Brothers, 1887

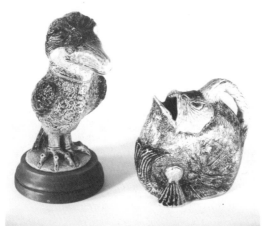

grotesque birds, heads and figures in harsh browns, greens and yellows. The modelling was of a high standard and fine coloured glazes were used, though in their time the figures were not greatly liked. The Martin brothers also made mask jugs, tobacco jars, candlesticks and clock cases in both neo-Gothic and Japanese styles.

William de Morgan (1839–1917) was the outstanding artist-potter of the late nineteenth century. His work has a perfection of shape and colour that is unrivalled. He delighted in the use of lustre in decoration and was influenced by Persian and Turkish shapes. His favourite colours were turquoise, green and blue. He used the peacock and the sunflower among other motifs, and his dishes, vases and tiles were decorated with birds, fish, floral and foliate subjects. Modern pottery fanciers tend to disparage de Morgan's work, but his skill and originality cannot be denied.

Examples of Victorian porcelain and pottery can be seen at the following museums and art galleries:

Bedford *Cecil Higgins Art Gallery*
Birmingham *City Museum and Art Gallery*
Bristol *City Art Gallery*
Cambridge *Fitzwilliam Museum*
Cheltenham *Art Gallery and Museum*
Derby *Museum*
Hanley *City Museum and Art Gallery*
Hove *Museum of Art*
London *Victoria and Albert Museum*
William Morris Gallery
Longton (Staffs.) *Gladstone Pottery Museum*
Manchester *City Art Gallery*
Mansfield (Notts.) *Museum and Art Gallery*
Newcastle upon Tyne *Laing Art Gallery*
Nottingham *Castle Museum*

Oxford *Ashmolean Museum*
Port Sunlight (Merseyside) *Lady Lever Art Gallery*
Rotherham (South Yorks.) *Clifton Park Museum*
St Austell (Cornwall) *Wheal Martyn Museum*
Open-air site museum of the Cornish china clay industry
St Helens (Merseyside) *Museum and Art Gallery*
Stoke-on-Trent *Wedgwood Museum, Barlaston*
Swansea *Glynn Vivian Art Gallery and Museum*
Telford (Shropshire) *Coalport China Works Museum*
Wolverhampton *Bantock House*
Worcester *Dyson Perrins Museum*

The following museums and art galleries, not already mentioned in this chapter, contain Victorian items of interest.

Bournemouth *Rothesay Museum*
Ipswich *Christchurch Mansion*
London *Bethnal Green Museum*
Oxford *The Rotunda*
Dolls' houses and contents
Reading *Museum of English Rural Life*
Scunthorpe (Lincs.) *Borough Museum and Art Gallery*
Stoke-on-Trent *Spode-Copeland Museum and Art Gallery*
Wakefield *City Museum*
Wolverhampton *Wightwick Manor* (National Trust)
William Morris wallpaper, tapestries, etc.; William de Morgan tiles

The extensive GLASS works of Messrs. BACCHUS and Sons, of Birmingham, furnish some beautiful examples of their manufacture, of which we engrave two groups, remarkable both for their novelty of form and of ornamentation. Several of these objects, it will be readily supposed, lose no little portion of their rich appearance in the engravings, where black only is made to take the

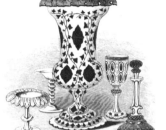

place of the most brilliant colours; this is especially to be observed in the large vase in the first group, where, if we imagine the lozenge-shaped ornaments of a deep ruby colour, cased with white enamel, and the wreaths of green ivy, we may form some idea of the rich effect produced. There are few objects of British manufacture which have, of late years, been marked by more decided im-

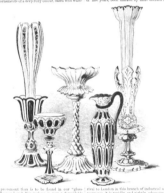

provement than is to be found in our "glass-houses," and Birmingham is now a formidable rival to London in this branch of industrial art; moreover, it is, rapidly, and rightly advancing

The three COAL-VASES, or, as such articles of domestic use are generally called, coal-skuttles, are from the establishment of Mr. PERRY, of Wolverhampton, who has, with much good taste, endeavoured to give a character of elegance to these ordinary but necessary appendages to our

"household hearths." Hitherto, in whatever room of a dwelling-house one happens to enter, the coal-scuttle is invariably thrust into some obscure corner, as unworthy of filling a place

among the furniture of the apartment, and this not because it is seldom in requisition, but on account of its unsightliness. Mr. Perry's artistic-looking designs, though manufactured only in japanned iron, may, however, have the effect of drawing them from their obscurity, and assigning them an honourable post, even in the drawing-room. It is upon such comparatively trivial matters that art has the power to confer dignity; and, notwithstanding the absurdity—as we have some-times heard it remarked—of adopting Greek and Roman models in things of little importance, they acquire value from the very circumstance of such pure models having been followed.

A page from the Great Exhibition catalogue, describing and illustrating items on display

PART TWO

VICTORIAN COLLECTABLES

Antimacassars

A crocheted or embroidered covering which was placed on the back of a sofa or chair to protect the upholstery from the oily hairdressing used by gentlemen. Oils and pomades began to be used on the hair at the beginning of the nineteenth century when powdered wigs went out of fashion. Bear's grease or macassar oil were commonly used by Victorian dandies, and the latter gave its name to the covering. Antimacassars in Berlin woolwork were the most popular kind, and there was a wide variety of materials and designs. Some were embroidered on net and silk and many were fringed. Antimacassars lasted in upper-class homes until the end of the century, though they survived in the parlours of the less fashionable for much longer. There was a revival after the First World War. In America they were often known as 'tidies'.

Barge ware

Heavy brown glazed earthenware with extravagantly applied clay flower decorations in primary colours. Typical examples are large teapots, made to hold four pints, jugs and bowls. The lid of the teapot is another teapot in miniature. Such articles were used by the people who worked the barges along the inland waterways. The earliest examples date from about 1850, and they were produced by small potteries in the Burton-on-Trent area until about 1914. A special feature of barge ware (also known as long-boat ware) is

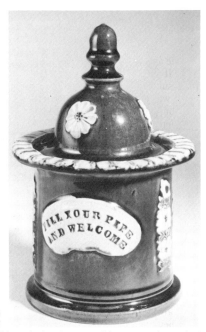

Barge ware
tobacco jar

the personal inscription impressed in a curved panel of white glazed clay which commemorated family events such as weddings and christenings. Others were simply inscribed 'A present to a friend'. Barge ware can sometimes be found in the Midlands and the Cotswolds area.

Baxter prints

George Baxter (1804–67) became a key figure in the great revival of colour printing in the mid-Victorian period by using oil-based inks and a succession of wooden blocks to build up the colouring in a single picture. The blocks overlapped to give fine gradations

of tone and colour, and often as many as 20 would be used. It was a painstaking and laborious process, but the results were masterpieces of printing, and Baxter's work was never superseded by that of his contemporaries or successors.

When Baxter was 20 he was illustrating books published by his father. He later went to London and was apprenticed to a wood engraver. His first colour print was issued in 1827 to celebrate his marriage, and in 1835 he patented a process for producing colour prints mechanically. His business was ruined in 1860 when the cheaper and easier method of reproduction called chromolithography became widely used, and in 1865 he was declared bankrupt.

Baxter prints were notable for their fine workmanship and the delicacy of the inks he used. They appeared first as book illustrations; later there were portraits, small landscapes, reproductions of Old Masters, a series on the Great Exhibition of 1851, and portraits of Queen Victoria and the Royal Family. The best Baxter prints have always been expensive for collectors, but in their day they were cheap and popular.

Baxter granted licences to other printers. They included Bradshaw (of railway guide fame) and Blacklock of Manchester; William Dickes; Kronheim and Company, who used zinc and copper plates instead of wood and who issued Christmas cards and small prints charmingly designed in clear colours; Joseph Mansell, whose work can be recognised by the vivid colours of the inks he used; and Abraham Le Blond. Le Blond produced prints by the Baxter process until about 1870, imitating the subjects and reprinting some of the most famous of Baxter's originals, though his prints did not have the fine detail of Baxter's. The prints of Le Blond and Kronheim are, after Baxter's, the most collectable.

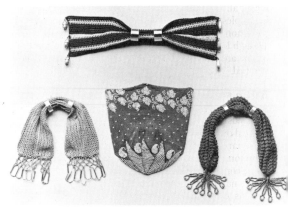

Beadwork bag and stocking purses

Beadwork

Many ladies in Victorian days had time on their hands. One of their pursuits was to decorate tea cosies, pincushions, firescreens, purses, garters, footstools, chair seats, curtains and other domestic articles with patterns and pictures made by sewing thousands of coloured glass beads on to a foundation of net, canvas or wool. Sometimes the beads were knitted together on threads before being stitched on to the surface. Sets of jewellery were also made by threading beads on fine waxed silk which were then made into necklaces, bracelets, brooches and hair ornaments. Small beads were preferred for fine work and large ones for decorating footstools, cushions and firescreeens.

One interesting example of beadwork is the 'miser' purse. It was a long, stocking-like bag with a purse at each tasselled end. At the centre were two slip rings

which allowed the user to open the section she wanted. Examples of beadwork are now difficult to find in good condition, but it is the cloth that will have deteriorated. Though beads may be missing those that remain are as bright and colourful as they were the day they were stitched.

Berlin woolwork

A kind of embroidery made by sewing coloured worsteds on to a canvas foundation, using a pattern printed on square-meshed paper and transferred square by square and stitch by stitch to the canvas. The most common stitches used were tent and cross stitch. The name comes from the German capital where two print-sellers named Philipson and Wittich first produced the designs early in the century and exported them to England. They became very popular about 1830, the fashion reaching its height about the middle of the century and causing all other forms of embroidery to suffer a decline. The wools were dyed in Berlin in a wide range of rather garish colours.

The earliest patterns were floral or pictorial, but soon well-known paintings were copied and framed. Religious subjects were favoured, so were three-dimensional representations of exotic birds and flowers. Family pets, especially King Charles's spaniels, were seen, and the infant Prince of Wales was a great favourite. Examples of Berlin woolwork were displayed at the Great Exhibition.

From about 1840 over 14,000 different patterns were being produced and the results covered stools, the seats and backs of chairs, firescreens, rugs and small sofas. After 1857, when analine dyes were invented, more wool was dyed in England, though the colours were harsher and liable to fade, and the quality of work

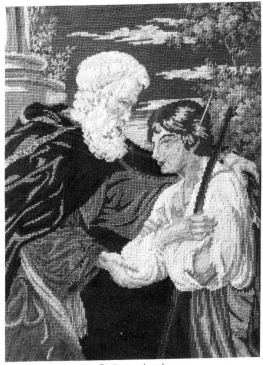

Berlin woolwork

declined. By 1880 the craft had begun to die out, ousted by the Art Needlework Movement, and soon afterwards it was quite outmoded.

Bookmarkers

Bookmarkers appear to have been used first in Tudor times. In the eighteenth and early nineteenth centuries they consisted of a narrow silk ribbon bound into the

Berlin woolwork panel

book at the top of the spine. The first detached bookmarkers, made of ribbon, appeared in the 1850s when books became cheaper and the standard of literacy was rising, and they were used chiefly in bibles and prayer books. They were often embroidered by hand and were in effect like miniature samplers. Sheets of strong perforated Bristol board, often edged with fancy borders, could be bought and designs could be worked

out using the perforations, which were spaced at about 500 to the square inch. The chosen design or text was then stitched with silk thread and the card was sewn on to a strip of ribbon. The craft was almost as popular as Berlin woolwork with both young and old. Up to about 1850 only pious themes were used, but the tradition was broken when small Christmas cards were stitched to silk ribbon.

Drawing and painting were domestic crafts much practised in Victorian times. They provided a clean, decorous and inexpensive occupation for middle-class girls, and many bookmarkers were hand-painted on stiff card. Some were religious, others might consist of a spray of flowers or a simple nature scene.

Woven silk bookmarkers were the speciality of the Coventry silk firms after 1860, when a tax on the import of foreign silk was lifted and a slump in the industry caused manufacturers to seek new ways of selling their products (see STEVENGRAPHS). By the end of the 1870s experiments with printing on silk were successful and printed silk bookmarkers began to appear in the 1880s. About this time too markers on thin card began gradually to replace the embroidered or woven silk type. Those with a religious theme were especially popular, and texts, nativity scenes or verses of hymns and psalms were given to pupils of Sunday Schools as rewards for good attendance. The firm of Mowbray, publishers of religious tracts, was particularly prominent in this field. Their markers had a semicircular flap cut to fit over the end of a page.

The commercial bookmarker also appeared in the 1880s. Brown and Polson, makers of cornflour, were among the first firms to issue bookmarkers advertising their wares. Mellin's Food for children, Bryant and May matches, and various brands of soap, candles, sewing

machines, corsets and perfumes were widely advertised. Book publishers and booksellers often inserted bookmarkers into every book they sold. The Scottish Widows' Fund, a life assurance company founded in 1815, used bookmarkers extensively at the end of the century. One of the company's designers was Walter Crane.

The advantages of collecting bookmarkers are that they are ubiquitous, they take up little space and can be displayed in albums like postcards, and are not expensive.

Bookmarkers, Coventry 1863

Buttons

The word 'button' was originally *bouton*, from the French *bouter*, to push. Buttons were first used as decorations on clothing and as fastenings in the sixteenth century. Mass production began in the eighteenth century. Among the materials used were copper, ivory and wood, and they were decorated with enamels, hand-painted miniatures or fine embroidery. Collecting nineteenth-century buttons can be a rewarding occupation and need not be costly. The field is wide, for the demand for buttons in those times was immense, and there are a great number of varieties to be found. There are those made of traditional materials, such as gold, silver, brass, mother-of-pearl and tortoiseshell, and others of glass and porcelain. Those made by Herbert Minton in the 1840s are distinguished by having two holes instead of four, with a shallow groove between them.

Some people collect single buttons of all kinds, others have a theme and concentrate on, perhaps, cut steel buttons, Wedgwood cameo jaspar ware, glass mosaic buttons, or military and livery buttons—those used by the fire services, the Post Office, the railways and the police. Some nineteenth-century buttons were die-stamped in silver and brass and came in sets, showing hunting and sporting scenes, for instance, biblical or classical themes, and nursery rhymes for children. Gilt metal buttons were often stamped on the back 'double' or 'treble'—which indicated the number of gilt coatings.

Though some sets of buttons are rare and fetch high prices at auctions, it is still possible to find bargains in button tins on market stalls or at jumble sales, and the impecunious collector need not be deterred from attempting to build up a collection of these attractive little works of art.

Card cases

Card cases

All through the nineteenth century middle- and upper-class ladies and gentlemen made a great feature of calling on friends and neighbours and leaving a visiting card. This custom was a social 'must', and the smarter the caller, the smarter was the case he or she carried their cards in. A card case was small, flat and rectangular, perhaps lined with velvet. It could be made of tortoise-shell, often mounted with miniature paintings, mother-of-pearl, ivory, papier mâché painted with flowers or

views, leather, silver, gold, and even bone china, though few of such fragile objects have survived. A widow, during her period of mourning, carried an ebony case. Do-it-yourself enthusiasts made cases of red or black sealing wax to imitate coral or jet.

In the early eighteenth century it had been the custom for playing cards to be used as visiting cards, with the caller's name written on the back, and all through Victorian times cards were larger than they are today and were easily bent: hence the need for a case to carry them in. Card cases are still plentiful in antique shops, and examples of modest quality are still reasonably priced.

Cameos

A cameo is strictly a small plaque, usually circular or oval, carved in relief with a variety of motifs from a hard stone—onyx, agate or sardonyx. It is an art that was first practised in Egypt, Greece and Rome. Over the years, however, the term has been extended to cover relief-carvings in softer materials such as mollusc shells. The cameos of classical times were carved from a stone of two or more differently coloured layers. The design was formed by cutting through the upper layer to reveal the layer or layers beneath which served as a background. In the eighteenth century there was a revival of the classical spirit in art and architecture, and the technique of cameo-carving was again practised.

In the nineteenth century many types of cameo work that did not come within the strict definition of the word were produced, among them those of Josiah Wedgwood, who carved white figures and topical and classical scenes on pottery. James Tassie, a Scotsman, and his nephew William were famous for glass cameos. Shell cameos were very popular too, and in Italy helmet

and conch shells were used. Lava cameos, sometimes called Pompeiian jewellery, were made from solidified volcanic residue, and were mounted in gold, silver or copper-gilt and made into bracelets, brooches and rings. Cameos were most popular as brooches in Victorian times and now, after a long period of neglect, are fashionable again.

Christmas cards

Christmas cards were unknown just over a hundred years ago. The forerunner of the card was the 'Christmas piece', which was an exercise in handwriting done by boys at school and taken home at the beginning of the Christmas holidays. It was written on paper with printed and coloured headings and borders, and contained greetings written in careful copperplate.

Christmas pieces had disappeared by about 1856. The credit for the first real Christmas card goes to Sir Henry

Victorian Christmas card

Cole, though it has been claimed that in 1842 the first card was engraved by a London boy named William Egley, whose card is now in the British Museum. But his effort aroused little interest and nothing came of his idea.

In 1843 Sir Henry Cole suggested to J. C. Horsley, an artist, that he should design a card about the size of a lady's visiting card, and Horsley produced a hand-coloured lithograph which consisted of three panels in a rustic framework. The central panel showed a family sitting round a table. On the left was a scene illustrating the phrase 'feeding the hungry' and on the right 'clothing the naked'. About a thousand of these cards were produced and sold at a shilling each.

In 1862 a publisher named Goodall began to print cards commercially, and on many of them the robin figured prominently. Christmas cards became very popular about 1870, and during the next ten years grew very elaborate. Some were shaped like fans, stars or half moons; some were frosted or studded with 'jewels'; others were made of silk, satin or even porcelain, and were hand-painted.

Cigar cases

Many more men smoked cigars in the nineteenth century than do so today—the habit became fashionable in France and Britain during the Peninsular War—and no smoker could be without his cigar case, whether it was made of decorated papier mâché, tortoiseshell with gold mounts, leather, ivory, horn or wood, the latter japanned or with mother-of-pearl inlay. Later in the century gold and silver monogrammed cases made by Fabergé were status symbols among the rich. Many cases were imported from the Continent, chiefly from Germany. Cigars were small and flat, and the cases were

small too, and D-ended, measuring about four inches by two inches. They can easily be confused with spectacle cases which, however, were narrower and had a pointed end. The more exotic cigar cases are beyond the small collector's means, but the less elaborate ones can be found at a less than ruinous price.

Cork pictures

These seaside holiday souvenirs, though not now commonly seen, were very popular in the 1850s and 1860s. Making cork pictures was a 'home' industry and was undertaken chiefly by house-bound women and invalids. These 'amateur' craftsmen built up landscapes, castles and classical ruins, inspired by Italian scenes and the novels of Sir Walter Scott, from pieces of cork, using dried moss for trees and shrubs. The picture had a background of black or crimson velvet, and was surrounded by artificial leaves and flowers and framed in maple wood.

Cottages

China cottages are believed to have originated in Holland during the eighteenth century. The earliest examples of the cottage in England seem to have been made by the Coalport and Rockingham factories and are now very expensive. They were usually about five inches high, though there are larger ones. Some were based on an existing cottage, others on an architect's drawing, and all were thickly encrusted with flowers in relief. China churches were made, too, and toll-houses and famous buildings. The most elaborate examples were made in the form of castles. 'Crime pieces' were models of notorious buildings such as the Red Barn in which Maria Marten was murdered, and Potash Farm, the house of the murderer James Rush.

The most common cottages, however, were of Staffordshire earthenware, and were produced in their thousands by cheap child labour. They were used by poor people and could be bought for a few pence from travelling salesmen. They were kept on the mantelpiece and were used as money boxes, night-light containers or as pastille burners to freshen the air in stuffy rooms. Pastilles were small cones made from charcoal, benzoin and gum arabic, and when ignited they gave off a sweet scent.

From about the mid-1840s cottages were simply ornaments. There are quite a number still on the market, though bargains are rare. Prices rose when American soldiers, stationed in Britain during the Second World War, discovered them and decided that they would make attractive souvenirs to take home. There are modern reproductions of the old cottages which look deceptively like the real thing, and care must be taken to establish the *bona fides* of a cottage before buying it.

Decanters

The decanter developed from the common bottle to the carafe for table wines in the seventeenth century, and then it was cylindrical in shape with a short neck and wide top for easy decanting from the wine bottle. The earliest examples were slim and light and were relatively free from ornament, but the style changed at the end of the eighteenth century, and decoration cut in deep relief was common. Square-section decanters, intended for spirits and liqueurs, in fitted cases with glasses to match, date from this time, and production continued into the nineteenth century.

By 1830 the decanter was undergoing a change. Sloping curves and pear-shaped stoppers were fashionable. Later still engraved glass replaced cut glass. In the

Glass decanter,
c. 1850

1850s the decanter's shape had become globular, with a long neck and spherical stopper. Patterns were engraved or etched. There were also matching sets of wine glasses, some coloured with decorations of trailing leaves. In about 1870 the round bottle-shaped specimen gave way to the 'Greek' type which was ovoid and footed. Cut glass returned at the end of the century, though it was less elaborate than when earlier in vogue.

Dolls

In medieval England pedlars visiting houses or from their stalls at country fairs sold carved wooden dolls,

(above)
Victorian dolls

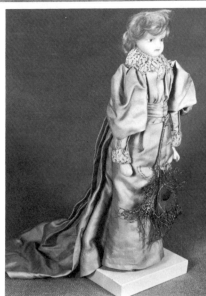

(right)
Doll, c. 1880

and in Elizabethan times jointed dolls were elaborately dressed. They looked like little adults, as did their owners. Nuremberg in Germany was famous in the fifteenth century, as it is now, for dolls carved from wood. The dolls of the eighteenth century and first part of the nineteenth were playthings for the children of the upper and middle classes (the children of the poor were too busy working in factories, sweeping chimneys, hauling trucks down mines or begging in the streets to have time or opportunity for playing). The eighteenth-century doll had glass eyes, usually brown and without pupils, and its wooden head was covered with gesso—a kind of plaster of Paris made from gypsum and glue. More attention was paid to its clothes than to its construction.

About 1825 dolls were wired for walking and sleeping, and were made of china, wax or papier mâché. After 1837 brown eyes changed to blue as a compliment to Queen Victoria. In about 1842 a very hard unglazed china called parian was invented, and because it was so fine, dolls' heads, necks and shoulders could be more delicately painted and looked more realistic. The rest of the body was made of cloth stuffed with horsehair or sawdust, though the arms from the elbow down and the legs from the knees up were also of china. Dolls that said 'Mama' or 'Papa' were operated by tiny bellows that worked when the arms were lifted or the body bent.

The Montanari family in England became famous for their wax dolls from about 1850. The early ones were heavy, but when they were given a papier mâché foundation they were lighter, and with real hair and eyelashes were both lifelike and beautiful. In the early 1860s two French firms, Jumeau and Bru, led the field. Their dolls had bisque china heads, extra large eyes and mohair wigs. Twenty years later dolls resembling adults

137

gave way to plump babies and little girls. German doll-makers led the international market until 1914, though the quality of their mass-produced efforts was inferior to that of the French.

Door porters

Objects used to prop open a door, they were also called door stops, and were made in cast iron, bronzed cast iron or, less often, in brass. They were made in the shapes of baskets of flowers, pineapples, winged lions, elephants, swans, eagles, dolphins and cornucopias, in addition to famous people such as Queen Victoria, Lord Nelson, Disraeli or the Duke of Wellington. They resembled Staffordshire pottery figures in their characteristic 'flatback' appearance. Usually there was some part of the figure which could be used to pick up the porter and move it when the door was closed. The Coalbrookdale Company in Shropshire specialised in iron porters; others were made at Lambeth in London.

Eventually door porters in other metals were manufactured, also in alabaster, terracotta and the green glass of Bristol and Wakefield. One popular variety was beehive-shaped. Some had flowers embedded inside, or were patterned with bubbles and tears. Cast iron porters have been reproduced in recent years, but are usually smaller than the originals and lack the sharp quality. Glass reproductions are too shiny and new-looking to be convincing.

Fairings

Fairings were small brightly-coloured porcelain groups in domestic situations which could either be bought as souvenirs for a few pence at a fair or were given away as prizes at sideshows. Their modern equivalent is the plaster Cherry Boy or Alsatian dog. They were crudely

138

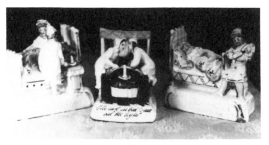

Fairings

made in large quantities by a German firm called Conta and Böhme and were designed principally for the British market. The most common groups are courtship and marriage scenes of a slightly bawdy nature, at least by Victorian standards. They had painted inscriptions in black or gilt, such as 'The landlord in love', 'Alone at last' or 'The last in bed to put out the light'. Maids in compromising situations were also popular.

About 1850 another type of fairing came on to the market, more sentimental and less indelicate: children, or animals dressed as humans. One example is a family of bears with the caption 'Coming home from the seaside'. When mass production became general fairings were lighter, coarser, and the colouring more slipshod. Rare models of the 'early to bed' type fetch high prices, but in general prices are still reasonable. Modern reproductions can mislead a novice collector.

Fans

Victorian fans were usually modelled on the folding crescent fan that first appeared in the seventeenth century. They were made in a variety of materials. The sticks were of ivory, tortoiseshell, mother-of-pearl or

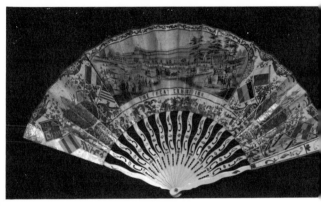

(above)
Printed paper
fan with
ivory sticks

(right)
Fan with
mother-of-pearl
inlay

sandalwood, and the mounts were lace, kid, silk or net. Black Chantilly lace and white Brussels or Honiton lace were most favoured. Fashionable women owned a number of fans to cover every occasion—walking, dancing, church-going, etc. Paper fans were turned out in their thousands to commemorate national events, and these are common and cheap enough for the beginning collector to concentrate on.

During the 1850s and 1860s fans seemed to lose some of their popularity, and even at formal evening functions they were not an obligatory fashion accessory, but in the 1870s the fan returned, more gorgeous than ever. The height of fashion was the fan with splendid ostrich or white cockatoo feathers which could be wielded with grace by the elegant women who could afford them. Peacock feather fans could also be seen at smart gatherings, and it became the custom to display them on drawing-room walls. Costly fans were kept in satin-lined boxes made of ebony, kid or goatskin tooled in gold or silver.

Firescreens

A feature of most Victorian drawing-rooms and parlours was the firescreen, used not only as a shield from the heat of a blazing fire, but also as a decorative piece of furniture to hide the empty fireplace in summer. In the dining-room, too, people sitting with their backs to the fire needed to be protected. The usual screen was mounted on a pole with a circular or tripod foot, and the panel was made either of papier mâché, needlework, woolwork or inlay. Berlin work was a very popular decoration.

Another kind of screen was the cheval screen, made of black and gold bamboo. It had two uprights, each on two legs, which enclosed the panel. Victorian young

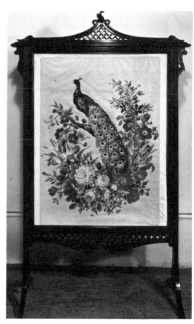

Embroidered
firescreen,
wool and silk
on canvas

ladies often painted pictures on glass screens or covered them with postage stamps. Lacquered and silk screens came from Japan and China, and towards the end of the century the William Morris movement was responsible for many fine needlework screens. Most firescreens that can be bought cheaply nowadays need restoring, but it is worth considering buying and repairing a down-at-heel specimen. Even if they are not used for their original purpose firescreens can make handsome ornaments.

Glass paperweights

Paperweights, or letterweights, as they were sometimes called, were first made in Venice, but the art was perfected in France in the factories of Baccarat, Clichy and Saint-Louis. It was not long before they were being copied in England, particularly in Stourbridge, Birmingham, Bristol and at the Whitefriars Glassworks in London. English paperweights lacked the brilliance and intricacy of the French. The Victorian examples which were mass-produced for a less affluent market are heavy, bun-shaped pieces of glass. The pictures showing through them are town and country scenes, famous buildings and people in national costume. This type is still cheap enough to collect.

The most sought after, and the most expensive, paperweights are the *millefiori* (thousand flowers) and *latticinio* (lattice patterns) types, and those with colourful enclosures such as birds, fruit, flowers or insects. Crystal cameo paperweights, originated by Apsley Pellatt, were produced between 1819 and 1865 and consisted of a cameo bas-relief in china clay embedded in flint glass. Such paperweights are difficult to distinguish from the French.

All Victorian glass paperweights are growing scarcer and becoming more expensive. Modern reproductions abound, and the collector must be careful not to buy one thinking it is an antique.

Goss china

A type of thin moulded porcelain with a slight iridescence in the glaze which was invented by William H. Goss of Stoke-on-Trent. Goss started potting in 1858 and for many years he specialised in producing exquisite little ornaments in parian ware. It was not until about 1892 that he began to make cheap though good quality

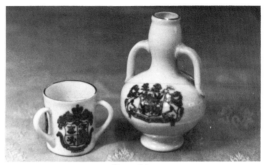

Goss china

porcelain in a variety of shapes, decorated with the coat-of-arms of a seaside resort, to be sold as souvenirs to holiday-makers. Although other firms produced similar objects Goss remained in the lead. The firm was renamed the Goss China Company in 1934, but ten years later the business closed down.

Goss's armorial china was not regarded highly by connoisseurs at the time. There was something vulgar, it was felt, about a Roman bucket with 'A Present from Blackpool' on it! Now pieces of Goss are collectors' items, are quite plentiful and can still be found at reasonable prices. Genuine old Goss crested china bears an impressed mark containing the initials WHG or WH Goss. There are many imitations to beware of.

Horse brasses

Horse brasses as we know them did not come into general use until the nineteenth century, and there were several different types, classified according to where they were worn on the horse. The single face brass hung over the forehead. There were two brasses hanging

behind the ears, three on each side of the runners at the shoulders, and up to ten on the strap running down the chest between the forelegs.

Few brasses are to be found that were made before 1850. The first and best were made of solid brass and were pierced by hand. Later they were lighter in weight and the designs were bolder. After 1850 many were cast in wooden moulds. These can be recognised by two or more small projections left on the back, traces of the studs or 'gets' which enabled the brass to be held in a vice.

Horse brasses are usually circular, with an upper rectangular part through which the strap was passed. Many different patterns have been devised. The crescent which represents Diana, the moon goddess, is the oldest and most often seen, and the sun is also common, either as a solid disc or as a small circle with added rays. Other popular designs include the heart, the human eye (as two semicircles side by side), stars, geometric shapes, card suits, country animals, and traditional emblems such as the Tudor rose. The brasses of railway horses had engines, dockyard horses had ships and anchors, and brewers' horses wore barrel emblems.

Genuine specimens of old brasses are becoming very rare. There are thousands of reproductions on the market, far outnumbering the originals. They are thin machine-made pieces, the backs left pitted and lumpy, and are of little value to the collector. A genuine brass is smooth and worn at the loop and at the foot where the horse's movements have caused the brass to rub against the leather strap.

Jet

Jet is a kind of black lignite or anthracite, is easy to cut and carve and can be highly polished. It has been used

for making ornaments from prehistoric times and was well known in Roman Britain. The main source was the coast of Yorkshire, especially at Whitby, where the finest quality is still found. In the late eighteenth century and all through the Victorian era the making of jet jewellery—necklaces, bracelets and brooches—was a thriving industry. Being black, such jewellery was in great demand during periods of mourning, and the average Victorian family, large and close-knit, was seldom free from a death. When the Prince Consort died in 1861 the whole country felt bereaved, and the jet industry was given its biggest boost. In the 1880s jet jewellery became fashionable in its own right, not just as mourning wear. The singer Adelina Patti wore it frequently and helped to popularise it for ordinary occasions.

Considering the enormous output of jet ornaments, it is surprising how comparatively few examples have survived. The choicest items to own are the long double and triple rows of faceted beads, serpent bracelets, bandeau combs, and neck-chains with large links. Household articles made of jet include paperweights, egg cups and thimble cases, and these are decided acquisitions to a jet collection.

Jigsaw puzzles

Jigsaw puzzles of a kind were invented in the second half of the eighteenth century by Wallis and Son, mapmakers, and were then called 'dissected puzzles'. They were intended as aids to education, as part of a lesson, not a playtime activity. The usual subjects were tables of kings and queens, historical events, maps of countries and snippets of geographical information. The printers and mapmakers who had their businesses near St Paul's Cathedral in London were the chief suppliers.

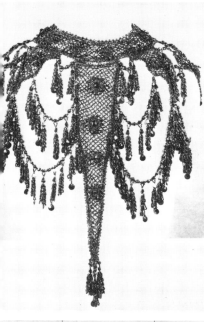

(left)
Cape of jet
beads

(below)
Dissected
puzzle

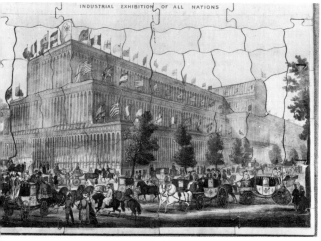

INDUSTRIAL EXHIBITION OF ALL NATIONS

The puzzles were expensive, costing between seven and twelve shillings each, a week's wages for a working man.

Few of these early puzzles have survived. This is not surprising considering the wear and tear at the hands of children they must have had and the likelihood of being lost, even though they were made of mahogany and packed in strong boxes with sliding lids. In the nineteenth century the themes of the pictures were highly moral and biblical subjects predominated. The Lord's Prayer was frequently found, and the downfall of Adam and Eve was common. The colours were applied by hand and the lettering was decorative. There were no intricate shapes and the few pieces did not lock together but were sawn up into odd-fitting shapes. It was not until the end of the century, when plywood was used, and when machinery could cope with the irregular tongue and groove pattern, that jigsaws became cheap and non-educational, and the range of pictures widened to include most of the subjects that we are familiar with today.

Matchboxes

Matches, known as 'friction lights', were invented by a Stockton-on-Tees chemist named John Walker in 1827. The stalks were made of cardboard and the heads were tipped with a chlorate of potash paste mixed with antimony sulphide. When drawn through a piece of folded emery paper they gave off a shower of sparks and a foul smell. They were sold in a metal tube with a lid, and cost a shilling a hundred.

Phosphorus replaced antimony sulphide in 1831, and matches became somewhat safer and certainly less smelly. They were now called 'Lucifers' or 'Chlorate Matches'. The first matchboxes were quite small, holding

only a few twopenny matches, and they had a serrated or grained edge. They were made in a variety of materials: tin plate, brass, gun metal, wood, ivory, pewter or silver, the latter being the most popular. They were usually rectangular in shape and one end was hinged. Others were circular or shaped like birds, animals, pillar boxes, barrels, crowns, even champagne bottles. Gentlemen kept them in their waistcoat pocket or hung them from a watch chain. Some boxes had an extra compartment for carrying a gold sovereign or postage stamps. Others were combined with a cigar-cutter. All had a groove at the bottom covered with ridges against which the match was struck.

The fashion of wearing matchcases came to an end when safety matches were introduced and the striking composition was put on the box itself. Bryant and May began manufacturing such matches in 1861, though J. E. Lundstrom of Sweden had invented the safety match in 1855. The new type of box consisted of an open-ended box fitting over the match container. By the end of the century they were being made of wood or cardboard, and decoration was an integral part. Adver-tisements for household goods appeared on the lids; non-advertising pictures included holiday resorts. Early advertisement boxes, being fragile, are not common; silver ones are found more easily. Decorative match-boxes died out about 1920. By that time matches were cheap and the box could be discarded when it was empty.

Money boxes

Money boxes have been made in England at most country potteries since the Middle Ages. In Elizabethan times an apprentice would hang up a clay bottle-shaped pot in the shop in which he worked and put in it the tips

he received from the customers, and he would smash it open on Boxing Day. In the nineteenth century the shapes, size and decoration of money boxes varied widely. They were made of metal, pot or wood (the latter less common), and all were gaily coloured. They can be found shaped like pigs and various other animals, hens and chickens, cottages similar to pastille burners, and human figures with open mouths. Between 1850 and 1860 some were made of fine bone china. The original 'piggy-banks' were of earthenware. They had a slit in the top and had to be broken for the money to be extracted. The name 'piggy-bank' is a reminder of the custom followed by country people in Victorian times when they saved strenuously to buy a pig. A pig in the sty meant real wealth. Fattened up and killed it would provide food for the family during the long winter months.

Square wooden boxes with painted lids had the advantage of lasting longer than the pottery variety. Victorian money boxes are still quite plentiful and are not expensive.

Moustache cups

Through much of Victoria's reign, and especially after the Crimean War of the 1850s, it was fashionable for men to grow long drooping moustaches. They may have caused women to sigh with admiration but they were a great problem to their owners when drinking tea in company. It was anything but elegant suddenly to exhibit a moustache with bedraggled wet ends! So moustache cups came into being, first made by Harvey, Adams and Company of Longton in Staffordshire, in about 1855. Eventually they were produced by every pottery in the country and even imported from France and Germany. A moustache cup was very like an

ordinary cup except that inside the rim on one side there was a little shelf with a hole in the middle. The moustache nestled on the ledge and remained dry while the tea was drunk through the hole. Such cups were made of every kind of ceramic material and were suitably decorated. Many were given to the male members of the family by wives and daughters as Christmas presents.

Moustache cups remained in use until the early years of this century, but after the First World War moustaches either grew shorter or disappeared altogether and a special cup was no longer needed. A collection of moustache cups is both amusing and decorative.

Music covers

Victorian England was the age of live entertainment. There were musical evenings in most middle-class parlours and more extravagant performances in taverns and music-halls, of which there were more than 500 in the London area alone. Songs were sentimental, patriotic, bawdy, tragic or humorous, and every performer of every class had his or her own repertoire and was willing to perform wherever there was a piano, harp or barrel-organ available. Thus there was a great demand for sheet music of every description, and the decorative covers of such sheets give a revealing picture of the social life of the times. It was a world of extreme wealth and dire poverty, of graceful couples dancing the waltz and mazurka, maudlin drunkards clutching their bottles, wistful brides saying farewell, comic policemen, ragamuffins turning cartwheels, and soldiers recruiting fighters for the Queen.

The application of lithography to the printing of sheet music not only gave it the status of an art form, but also brought it within the reach of mass-production printers,

and in the 1840s the advent of chromolithography meant that the illustration became more important and took up the whole of the front cover. During the nineteenth century there were over 100,000 music covers produced in England and about the same number in America. The music sheet can, in fact, be compared to today's pop record and was just as effective in bringing popular music to the masses.

Two of the best-known artists in the field were Alfred Concanen (1835–86) and John Brandard (1812–63). In France Toulouse-Lautrec designed some covers, and George Cruickshank ('Phiz' of *Punch*) was also a practitioner, though his main work was in books and magazine illustrations. The general level of craftsman-ship was high, but often taste and discrimination were lacking, and the less gifted artist produced crude and sentimental work. Towards the end of the century standards dropped and letterpress and half tone photo-graphic illustration ousted the artist. Some of the music publishers who were operating a century ago are still flourishing, among them Novello's, Boosey's, Chappell's and Francis Brothers and Day (now Francis, Day and Hunter).

The scope for collecting music covers is wide, and many collectors specialise in one particular aspect: military uniforms, for instance, or songs about Royalty, Italian opera, the Crimean War, the American Civil War or the opening of the American railways.

Nest eggs

This particular kind of container for eggs was first produced by Staffordshire potters in the mid-nineteenth century and was modelled in the form of a nest or a basket with a broody hen on the cover. Occasionally ducks, geese or swans were used. A nest egg could be

used in the pantry to store eggs in or on the sideboard in the dining-room to keep egg cups in. The storage nest eggs had crude but lively colours, but those for the dining-room were of porcelain or electroplate, the latter having a matching stand and a glass liner that could be taken out.

Papier mâché

The unnecessarily exotic French name given to moulded pulped paper. It used to be called 'paper ware', a more reasonable term. It was used for articles both large and small, and was particularly suitable for polished japanned trays, boxes, tea caddies, blotters, inkstands and letter racks. Wardrobes, screens, tables and chairs were also produced, though such furniture often had to be strengthened with wood or metal.

The process of moulding paper originated in the East and came to England via France in the seventeenth century. It was then made of paper pulp, glue, chalk, plaster, sand, sizing and gum mastic, poured into a mould and allowed to harden in slow heat. It was used for mouldings, wall and ceiling decorations and picture frames. In 1772 Henry Clay of Birmingham devised and patented another method. He laid pasted sheets of paper into a wooden mould where they were pressed into shape and afterwards stoved, smoothed and japanned or varnished. Clay began to manufacture a wide range of products, though the tray was the most popular. During the first half of the nineteenth century Jennens and Bettridge of Birmingham were the foremost producers of papier mâché articles of fine quality and beautifully decorated; some were inlaid with mother-of-pearl. A set of three trays decorated with foliage, birds and fountains was made to commemorate the wedding of Queen Victoria and Prince Albert in 1840.

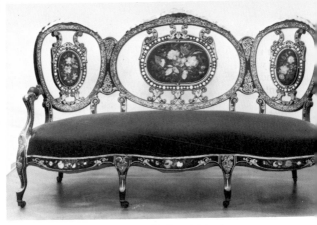

Papier mâché sofa

The firm was prominent in the Great Exhibition of 1851.

Papier mâché furniture was especially popular between 1840 and 1880. It was made in France, America (where clock cases were specially favoured) and in England, chiefly in Birmingham and Wolverhampton. Much of the decoration was in the Oriental style. Flowers, ferns, romantic moonlight scenes, ruined Gothic abbeys, triumphal processions and naval victories were all common. Among the best-known artists who decorated trays were Edwin Haseler, George Neville and Joseph Booth.

The first papier mâché articles were made for the upper end of the market, which was later flooded with gaudy and inferior items, mass-produced, on which hand-printing had given way to transfers. Good-quality papier mâché is Victoriana at its best, and although there is still a fair amount on the market it is not easy nowadays to find the best items cheaply.

Parian ware

Parian ware is a type of biscuit porcelain. At the Copeland factory in the early 1840s a material was accidentally discovered that could be moulded while still in a liquid state and which resembled marble. Several firms then began to produce portrait busts, statuesque ladies in flimsy draperies or replicas of famous pieces of sculpture, such as the Venus de Milo, in a size that would fit into a drawing-room. Originally such pieces were called 'statuary porcelain'. Wedgwood gave the name 'Carrara' to his firm's products, but Minton's name was 'Parian', and that has become the most common. The characteristic ivory tint of parian ware was thought to resemble the marble found on the Greek Island of Paros.

The more ambitious examples of parian ware consisted of several figures and were mounted on metal stands. There were some very much admired pieces at the Great Exhibition of 1851 and the New York Exhibition of 1853. Domestic articles were also made of parian ware. Jugs were usually decorated in relief and glazed outside. Life-sized figures were made to stand in gardens. One of the largest manufacturers was the firm of Robinson and Leadbeater of Stoke-on-Trent, who flourished from 1885 to 1924.

Parian ware lost some of its popularity among the well-to-do when a technique was evolved to make the ware withstand boiling water and the market became flooded with articles of poor quality.

The ware appeared in America soon after its discovery in England, chiefly as portrait busts and parlour ornaments. Much of it, both in England and America, was too sentimental for modern tastes, its creamy whiteness giving it a feminine quality, though the skill of the modellers is still admired.

Pincushions

The variation in material, colour, shape and size of Victorian pincushions is almost limitless, but without exception they were charming and decorative. Some were made of velvet, some of silk or taffeta, and they were stuffed with horsehair and embroidered with mottoes. They could be square, circular or heart-shaped, or take the form of animals, birds or fruit. Others, which had wooden or ivory bases, represented buckets, warming-pans or bellows. There were urns, vases, miniature wheelbarrows, spinets and high-button boots.

Expectant mothers could hope to receive a pincushion of white satin adorned with coloured silk ribbons bearing a tender message pricked out in bead-pins or embroidery, welcoming the 'sweet babe' and hoping that it would prove to be a blessing to its parents. The sex of the sweet babe was carefully not mentioned. Some pincushions were sent out as Christmas gifts and bore seasonal greetings, and soldiers and sailors away from home would make rather crude examples embellished with flags or ships and present them to mothers and sweethearts.

Posters and playbills

The earliest printed paper posters appeared in Germany in the second half of the fifteenth century and in England soon afterwards. The first illustrated posters of the seventeenth century were crude wood cuts. Trade posters consisted entirely of letterpress with contrasting sizes and styles of typeface to give variety. It was not until lithography became a commercial process, after its advent in 1795, that pictorial posters were produced on a large scale. Their growth as an advertising medium was phenomenal. Jules Cheret was a pioneer; his first theatrical colour poster appeared in 1867 and brought

to notice the name of Sarah Bernhardt. During the next 30 years Cheret designed over a thousand different posters, not only for theatrical purposes, but also as advertisements for chocolates, cigarettes, corsets, laxatives and bicycles.

Most of the posters seen around today belong to the 1890s and after. In France Toulouse-Lautrec designed posters advertising the Moulin Rouge; Alphonse Mucha portrayed Sarah Bernhardt in some of her great roles; Steinlein and Willette are other famous names. Fred Walker's black and white poster for Wilkie Collins's *Woman in White* was the forerunner in England, and after him Aubrey Beardsley, Walter Crane, John Hassall, Will Owen, Gordon Craig and the Beggarstaff brothers produced outstanding work. Sir John Millais's 'Bubbles' became an advertisement for Pears's soap, and W. R. Frith's 'The New Frock' was also turned into a soap commercial. In America theatrical posters were first produced in 1889. Will Bradley and Maxfield Parrish designed posters advertising Scribner's and Harper's magazines, and later Charles Dana Gibson and Ethel Reed did distinctive work.

Pot lids
Pot lids are the small round covers designed for the shallow pots in which bear's grease pomade for gentlemen's hair was originally sold, and later such preparations as shaving paste, toothpaste, potted shrimps, fishpaste and meat relish. They were decorated in polychrome underglaze transfer-printing with incidents from Victorian life and activities, religious and topographical scenes, and portraits. Over 300 patterns have been recorded, the rarest being the early bear motifs. Pot lids were specially made for the 1851 Exhibition, and later exhibitions were also commemorated. The

pomade pots had rather a short life, but a great impetus came from the fishpaste industry which was centred on the Kent coast, and Pegwell Bay lids are still quite common.

F. R. Pratt and Company of Fenton in Staffordshire were the specialist manufacturers, their products being particularly successful between the 1850s and 1860s. The multicolour printing process was developed by Jesse Austin, a member of the company, and his name or initials are to be found on some examples of his work. Other pot lid makers include Charles Ford of Shelton, John Ridgway of Hanley, and Mayer Brothers and Elliott. Towards the end of the century there was a flourishing export trade with America, and these lids were decorated with scenes from American history.

Rolling pins

Rolling pins made of glass are collectors' items of great interest, but authentic items have become scarce. Those made early in the nineteenth century were hollow, with a stopper at one end, and were used as storage jars for sugar or salt, to keep them free from damp. Salt was extremely expensive, due to the tax which was thirty times greater than the cost of the salt itself. The 'Bristol roller' appeared during the Napoleonic Wars. Many sailors gave rolling pins to their wives or sweethearts, and it is common to find a nautical motif as part of the decoration. If such a present were accidentally broken it was believed that the sailor's ship would be wrecked.

Other rolling pins were made of solid dark bottle glass, either blue or green, and were often flecked with enamel glass and embellished with gilt scrollwork—a speciality of the Bristol and Nailsea glassworks. Opaque white rolling pins with incised coloured decoration could be bought as mementoes of a visit to the seaside,

Sunderland glass rolling pin

and were popular between about 1830 and 1860. There were also clear glass rolling pins with looped striations in pink and white. Glass rolling pins, filled with water, were used for rolling out pastry or, filled with salt or sand, for ironing clothes. The usual custom, however, was to hang them up over the chimney or on a wall as a charm against the evil eye.

Rolling pins which look like the Victorian originals have been reproduced in tens of thousands, and because they look old the unwary collector may be easily deceived.

Samplers

A sampler is, as the name suggests, an example—in this case, of skill in design and stitching. In the nineteenth century most samplers were stitched by children, who used a fine cross stitch. They took up hours and hours of time, both in the design and the execution, and they were worked either at home or at the 'dame' schools the little girls attended. Occasionally boys tried their hands at them too. A typical sampler contained the letters of the alphabet or a line of numbers bordering a scriptural quotation, a moral sentiment or verse or the Lord's Prayer. Birds, fruits, flowers, animals or trees also formed part of the decoration. The sampler was often finished off with the name and age of the child and the date. There are many examples of such child art about, naive and charming, a reminder of the days when a

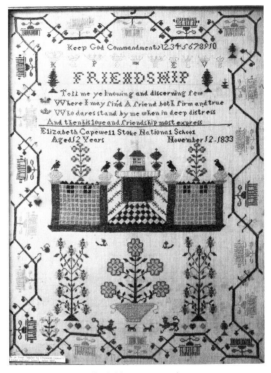

Early Victorian sampler

woman needed to be a fine sempstress in order to provide most of the family's clothes. The delicate silks that the upper classes had once used gave way to wool, and the subjects of the pictures were influenced

by the stern and primitive religious sentiments of John Wesley.

About the middle of the century the fashion began to die out, and after 1870 few samplers were made. Those of the later period were stimulated by the publication of sampler patterns in England, America and Germany. The results were less individual, less ambitious and less attractive than the earlier instructional and ornamental samplers. But even good early examples can be found at reasonable prices.

In America sampler-making, which tended to be more pictorial than the English variety, died out after the 1830s, when design and workmanship had deteriorated. The growth in popularity of Berlin woolwork put an end to the individual expression of the early Victorian products of childish fingers.

Scent and smelling bottles

Early scents were usually based on powder and were kept in leather sachets. It was not until the seventeenth century that ladies used silver bottles for sprinkling flower water about the house. In the eighteenth century figure bottles in porcelain with stopper heads and gold-mounted neck collars were fashionable; they are now extremely expensive. The manufacture of glass scent bottles in the eighteenth century is usually associated with Bristol, where glassmakers produced a brilliant blue glass as well as an opaque one.

As some perfumes deteriorate when they are exposed to light, coloured or opaque glass was commonly used, but in the early nineteenth century the vogue was for crystal cut glass, and in the second half of the century light red Cranberry glass scent and toilet bottles, decorated with enamel and gilding, were made at Stourbridge. Smelling bottles, which contained essences

and aromatic vinegar to prevent fainting fits, were made in large numbers, as were bottles encased in filigree silver mesh and hung from chatelaines.

Bottles made of gold, silver and enamel are rare. Porcelain bottles, much less common than glass, were plain in shape but elaborately decorated. Tinted porcelain bottles with silver screw tops bore coloured transfer prints of country scenes. In the 1870s and 1880s there was a craze for scent bottles made in two parts to serve two purposes. Two separately made bottles were joined together at their bases. One contained smelling salts, kept in by a stopper or a hinged lid which was opened by pressing a stud; the other held perfume which was exposed by unscrewing a threaded metal cap.

Victorian scent bottles appeared in a wide variety of shapes and sizes, in plain clear glass crystal, vaseline glass, opaque white and turquoise blue. The stoppers were often of richly decorated silver and can be dated from the hallmarks if the silver is above a certain weight. Some of the most beautiful bottles are those of richly cut crystal with silver mounts and gorgeous stoppers which were made to stand on dressing-tables.

At the end of the century some of the leading French perfumiers commissioned Gallé, Lalique and Dawm Frères to produce magnificent little bottles of pressed and moulded glass, acid-etched and engraved cameo glass, and plated fancy glass; these are highly collectable and very expensive. But the more modest Victorian scent bottles, which were often sold at country fairs as lovers' keepsakes, decorated with colourful transfer prints, are comparatively inexpensive.

Scrapbooks

In the 1850s and 1860s filling albums with shells, fashion plates, flower pictures, Christmas cards and

Valentines, embossed crests and monograms from envelope flaps, was a favourite occupation of ladies with plenty of leisure. Drawings, watercolours and home-made verses were often interspersed with the pictures. At the height of the craze, which was called decalcomania, it was possible to buy sheets of coloured subjects suitable for cutting out and pasting in, and there were also stamp dealers who published sets of crests and special albums for them. But the advent of cheap mucilage-backed printed scraps turned the hobby into a child's pastime and young ladies began to lose interest. The best scrapbooks are those produced between 1850 and 1890 when the pictures and scraps were tastefully and artistically arranged and had an adult appeal. They present a fascinating glimpse of a vanished age.

The folding draught screen, decorated with pictures and scraps, was an essential part of the Victorian nursery, and many were most attractive in a bizarre way, a riot of animals, birds, flowers, children, fairies, landscapes and seascapes cut from the coloured prints of the day, greetings cards, chromolithographs and commercially produced scraps. Unfortunately, not many have survived in a pristine condition, but if they are not too far gone it is possible to restore them to an approximation of their original state by a judicious use of bits of 'modern Victoriana'.

Scrimshaw

An art first developed by New England whalemen and sealers to fill in their time on their voyages from the North Atlantic to the South Pacific during the early years of the nineteenth century. Later it was practised by sailors in many parts of the world. It was a process of engraving on the ivory teeth of the sperm whale, on

whalebone or on walrus ivory, using knives and ships' tools. The most popular subjects were ships, whaling scenes, eagles and human figures, and intricate and beautiful work was often produced by these amateur craftsmen. A tracing was first made from a design and pricked out in the material. The pricks were joined by thin scratches which were then blackened and the whole thing polished with china clay and whale oil. Work boxes, spool-holders, clothes pins, rolling pins, knife handles, napkin rings, umbrella handles, cane heads and stay busks (oblong strips of whalebone used as corset stiffeners and given to wives and sweethearts as love tokens) were among the products of scrimshaw.

The art of scrimshaw spread inland to the frontier towns of the Middle and Far West. Animal horns were turned into powder flasks and decorated with hunting and pastoral scenes or with portraits of the old Wild West folk heroes. Scrimshaw was still being produced late in the century when the American Civil War and the Spanish-American War gave impetus to the art.

Scrimshaw

The origin of the name is obscure and many versions of it exist. In Melville's *Moby Dick*, published in 1851, it is called 'Skrim shander'.

Shaving mugs

The shaving mug was in its heyday from about 1830 and lasted until brushless shaving cream, safety and electric razors superseded the open cut-throat razor. The real home of such mugs was in America, and a large number of patents were granted for their manufacture. There was a wide variety of shapes and styles; some were simple and squat, others had a pelican-shaped mouth; the Utility model incorporated a razor-holder, brush compartment, hot water bowl and a sliding drawer underneath for the soap.

Shaving mugs were made chiefly of pottery or porcelain, though some were made of silver or brass, and floral decoration was rife. Souvenir mugs sold in large quantities in seaside resorts and were decorated with a transfer-printed view of the town. It was a common practice for ladies to give their menfolk a mug inscribed with tender exhortations such as 'Remember me'.

Barber shop mugs were a feature of American domestic life and are eagerly collected. The vogue began in the 1870s. The mug was embellished with the customer's name and perhaps a vignette representing his trade or profession, and was kept in a rack until that particular person turned up for his shave. After the First World War the manufacture of barber shop mugs declined rapidly.

Ships in bottles

Ships in bottles were very popular in the days of sailing ships and are a strong link with Britain's maritime past.

Although a few examples have been recorded from the late eighteenth century the great majority began to appear from about 1840. They were produced in great quantities by sailors on long voyages, and also when they were on shore leave. Some of them were very elaborate indeed; the carved and rigged models of famous ships were perfect in every detail. The simpler, cruder examples can still be picked up cheaply, but the better ones are scarce and costly.

The bottle most often used had a globular or oblong body and a slender neck. The method of getting the ship into the bottle is no longer a mystery. The hull, with the masts and rigging laid flat, was inserted into the bottle and thread lines were used to pull them up into position. The 'sea', which had to be in place before the ship, was made from coloured plaster of paris or a mixture of cork, putty, sand and glue. It was poked into the bottle with wire or a needle, then glued into place. The inside back and foot of the bottle were painted to represent sky and coastline. When the ship was in position the ends of the draw threads were burned off and the bottle was corked and sealed. Modern reproductions are usually of poor quality; authentic examples are easy to distinguish.

Staffordshire figures

The late nineteenth-century cottage would have been incomplete without at least one pottery Staffordshire figure or chimney ornament, as they are sometimes called, and they are probably the best-known form of antique that exists. There was an enormous demand for dogs (cats are rare), farmyard animals, shepherds and shepherdesses, historical personages and events. In fact the range of subjects is almost endless, ranging from the Royal Family to notorious criminals, and many were

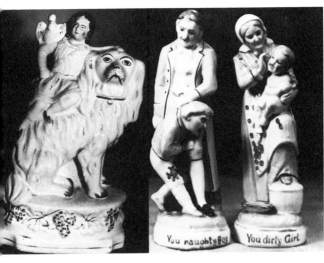

Staffordshire figures

inspired by magazine illustrations and music covers. Often the same mould was used for several different subjects.

Several factories in the Midlands and north of England were devoted almost entirely to the production of such figures. There was also a substantial cottage industry. The whole family would take part and earn a penny for every dozen articles. Eagles were made for the American market, as were politicians such as Washington, Franklin, Jefferson and Lincoln. Porcelain figures went to decorate rich drawing-rooms; the earthenware specimens were destined for cottage chimneypieces. The latter can still be found for relatively

small sums and in spite of chips and cracks they can be the basis of an attractive collection.

Very few of the earthenware figures bore a maker's mark and are known as 'Staffordshire' wherever they were made. Those designed for rustic taste are crude and sentimental but they all have a certain vigorous charm. The most familiar figures are the upright spaniels in brown and white and the greyhound reclining on a blue base. Figures which had very little modelling or decoration at the back are known as 'flatbacks', and they began to replace figures modelled in the round about halfway through the century, though their heyday was over by the 1870s. They were ideal for chimney-pieces where brown-eyed spaniels vied with kilted Highlanders and milkmaids for pride of place.

Probably over 600 different Staffordshire models still exist. Some are very rare; these include the marriage of Queen Victoria and Prince Albert, Jenny Lind the singer, Florence Nightingale, and Amelia Bloomer the American feminist. The commoner models are the ones which have survived in any quantity. The collector of Staffordshire figures must guard against modern reissues artificially aged.

Stevengraphs

A Stevengraph is the trade name given to the woven silk picture which was manufactured by Thomas Stevens (1828–88). For hundreds of years the city of Coventry had been famous for silk ribbons, but just after the middle of the nineteenth century a slump in the business, caused by the removal of a ban on imported silks from Europe, had caused acute unemployment, and thousands of weavers were looking for other kinds of work. In order to meet the Continental challenge Thomas Stevens adapted the Jacquard loom

and experimented with the production of bookmarkers and other small decorative items. He established his factory in 1854 and almost immediately a great industry was in being. The market for its products lasted until the First World War, and though it declined in later years the factory still functioned until it was bombed in 1940. Embroidered hat ribbons, badges, Valentines and scent sachets were among the items turned out by the Stevengraph factory, but it is best remembered for the picture woven in coloured silks. The picture was usually $8\frac{1}{4}$ inches by $5\frac{1}{4}$ inches and was mounted on a green (later biscuit-coloured) background, with the title and Stevens's name on the front and the name repeated on the back. In 1879 Stevens gave demonstrations of Stevengraph productions at the York Industrial Exhibition, and they became more popular than ever.

The subjects of the Stevengraphs included famous sportsmen, sporting scenes, fox-hunting, regattas, historical tableaux, early locomotives, and those with Coventry connections such as Lady Godiva and Peeping Tom. Portraits of royalty, statesmen and contemporary personalities were also in great demand; and there were many with an American slant as Stevengraphs were widely exported. Silk pictures cost very little when they were first made but nowadays are quite costly collectors' items.

Tea caddies

Tea became a national drink in the late seventeenth century, but it was extremely expensive, partly because of the cost of bringing it to England and partly because of the heavy duty imposed on it. Tea supplies, therefore, even in wealthy households, had to be carefully guarded (it was not a drink for servants), and a tea caddy (originally called a chest or canister) which could be

Japanned papier mâché tea caddy, 1851

both ornamental and practical with a lock and key was the answer. The word 'caddy' is derived from 'kati', a Malay unit of weight equal to about half a kilogram.

The earliest tea caddies were plain wooden affairs and were lined with pewter or lead foil, but those of the late eighteenth century were usually made of mahogany and were elaborately carved. There were two compartments, one for green tea, one for black. Some larger caddies had a glass liner for sugar between the two varieties of tea. Ebony caddies with octagonal or oval sides edged with ivory were fashionable later in the century. There was also a vogue for marquetry and highly painted papier mâché. Silver caddies were delicately decorated.

Early Victorian caddies were made of mahogany, walnut, rosewood or satin wood and were often edged

with bands of mother-of-pearl, bone or ivory. The earliest had tapering sides so that the base was smaller than the lid. When tea became cheaper and was less worthy of a good setting, caddies were less ornamental and cheaper to construct, and were thus produced in large quantities. The commonest Victorian caddies found today are tins embellished with pictures, the most desirable being those commemorating royal occasions.

Tiles

Thin slabs of ceramic material, usually made of earthenware, but sometimes of porcelain, marble or glass, have been used for covering floors, walls, ceilings and for fireplace surrounds for at least six thousand years in Europe; they were also made in Japan and China in pre-Christian times. In the twelfth century tiles were used for the floors of cathedrals and churches. From the end of the sixteenth century delftware tiles, favouring blue and white designs, were produced in Holland in large quantities and exported to England. After the Dutch wars of the 1660s and 1670s and the cessation of trade between the two countries an English delftware industry grew up. It flourished in the second half of the eighteenth century and again from 1840 onwards. From about 1756 hand-painted tiles gave way to transfer-printing from copper plates. Pastoral and hunting scenes, biblical subjects, portraits of well-known people, and later scenes from Dickens, were among the pictures on the tiles which decorated Victorian fireplaces and walls.

During the Gothic Revival the potteries of Stoke-on-Trent turned out vast quantities of unglazed tiles with medieval designs. Minton's encaustic tiles, red clay inlaid with a design in white clay burnt in, were used for such diverse purposes as a pavement for Queen

Victoria's Osborne House, eleven cathedrals, the Capitol Building in Washington and the Royal Albert Hall in London. From the Wedgwood factory came sets of tiles with scenes from *Little Red Riding Hood* and *A Midsummer Night's Dream*. Minton's and Doulton's were the two firms which produced the finest tiles; from the former came glazed earthenware maiolica tiles with relief decorations. But the most prolific tile-maker of all was William Maw of Brighton, who started in the 1850s and by the end of the century owned the largest tile pottery in the world.

Pugin, the Pre-Raphaelites, Ruskin and William Morris brought medievalism back into tile designs and created the most decorative tiles of the century. William de Morgan, designer friend of Morris, established himself in Chelsea in 1872, then, after a period at Merton Abbey in Surrey, returned to London to the Sands End Pottery in Fulham, with which he was associated until 1907. He made tiles which featured birds, fish, flowers, ships and mythical beasts, and in the 1880s was particularly attracted to the peacock and sunflower. His 'Isnik' tiles, with designs related to sixteenth-century Anatolia, were striking examples of creative imitation.

De Morgan's work had a lustrous quality, rich subtle colours and a style both restrained and lyrical. One of his commissions was to supply tile pictures for the Czar of Russia's yacht; later he decorated six ships for the P. & O. Line. Examples of his work can be seen in Leighton House and the William Morris Gallery.

Victorian tiles come in endless variety. Pictorial and patterned tiles were made for kitchens and bathrooms as well as for the drawing-room, skirting-boards and dados, and were also common in butchers' shops and dairies. They are still reasonably priced and can be framed singly or in sets, stuck on a board and hung as

an unframed picture, or laid round a fireplace or above a wash basin or sink unit.

Tobacco boxes

Tobacco boxes were used extensively between about 1750 and 1850. Most of them were made of lead, brass or cast iron, with relief decoration on the sides, and lids with a fancy handle which was often shaped like a Negro's head. The boxes were painted and gilded and inside was a tobacco press—a flat lead disc with a knob that kept the tobacco pressed down and the box airtight. They were displayed on a sideboard or mantelpiece.

Tobacco jar,
jet ware

Tobacco boxes were often given to soldiers going off to war, from the Crimean War to the First World War, and many of them carried regimental or club crests. When tobacco could be bought in ready-cut form and was kept in a leather pouch the use of the tobacco box declined, and a further blow to its popularity was given when tobacconists sold tins of tobacco that could be kept in the pocket.

Toby jugs

In 1761 the Rev. Francis Hawkes published his *Original Poems and Translations*, and one of the poems, translated from the Italian, told of the life and death of a hearty and corpulent drinker called Toby Fillpot. An engraving of Toby Fillpot inspired the elder Ralph Wood of Burslem to manufacture earthenware ale jugs in Toby's image, and so the first Toby jugs appeared. Other Staffordshire potters began to produce their own versions of the rotund figure with his brimming tankard and clay pipe, and they have been made down to the present time. Victorian Toby jugs were inferior to the early ones, and modern ones, mostly imitations of the eighteenth-century types, usually lack the vigorous colouring and artistic quality of the originals.

Toby appeared in many guises—as sailor, parson, night watchman, convict, John Bull, Silly Billy and Paul Pry. There were female Tobies too—Martha Gunn, the Brighton bathing attendant who used to dip the Prince Regent, the Gin Woman, who had coarse features and a pronounced moustache, and Judy, wife of Punch. Bluff King Hal in Tudor costume is supposed to be based on the Prince Regent, and some of the naval heroes of the eighteenth century appeared as Tobies.

Most Tobies are seated, but there are also standing types. Many carry inscriptions of the 'fill it again'

variety. Many of the earliest jugs were unmarked and modern fakes can confuse the inexperienced collector.

Treen

Treen is the collective name for all small objects made of wood, especially small domestic articles. Victorian treen includes a large number of items in finely carved or polished wood, made by skilled craftsmen, which can still be found in quantity and at reasonable prices. Spoons, bowls, cups, trenchers, platters, egg cups and butter moulds are typical examples. The wood used was generally oak, elm or sycamore. People who could not afford tableware made of pottery or pewter used treen, but as the use of earthenware increased, treen was less in demand.

Tunbridge ware

A form of wooden ware that imitated mosaic work. It was produced in and around Tunbridge Wells in Kent, chiefly in the first half of the nineteenth century, but also in the first part of the present century. The last work produced in Tunbridge Wells was in 1927, when the firm of Boyce, Brown and Kemp, founded in 1873, was wound up.

The ware was made by local craftsmen to sell to visitors to the famous spa. All kinds of objects were made, from egg cups and inkstands to reading desks and games tables, but the most usual objects were boxes of all shapes and sizes: for snuff, stamps, writing materials, dominoes, jewels, gloves, handkerchiefs, cigarettes and matches. The boxes were decorated with tiny wood mosaic patterns applied in a thin veneer, the decorations being either a rigid geometric pattern or a mosaic picture of flowers or scenes. Another variety had a marbled effect. Working from a pattern on

Tunbridge ware

squared paper, the craftsman composed the picture by arranging and gluing together fine, long and accurately cut 'matchsticks' of different coloured woods so that the finished bundle had the picture running through it, rather like seaside rock has 'Blackpool' or 'Brighton' all the way through. Slices of the block, less than one tenth of an inch thick, were cut, glued to the plain wood, sanded and polished. Later, owing to machine-cutting, the slices were wafer-thin. One bundle could thus give many identical mosaics as a result of a single design operation. Some later work was varnished. For the most elaborate work over 150 different woods could be used, many from trees grown in the neighbourhood. Beech, pine and oak were used for the less expensive boxes, rosewood and sycamore for those of better quality. The woods were coloured by vegetable dyes only, and staining effects could be achieved by soaking the wood in the local spring water.

The process was long and laborious, and could only be done in an age in which leisure was plentiful. In the

Tunbridge ware

Great Exhibition of 1851 a mosaic table was on show, the top of which was made up of 129,000 pieces of wood.

Tunbridge ware offers quite a lot of scope for the small collector because, being so popular and so abundant, there are still many examples around. The best pieces come from the first half of the century; later the manufacture became mechanised and some of the quality and style of the earlier work was lost. The most notable producer of Tunbridge ware was Thomas Barton (1819–1902).

Valentine cards

Since medieval times it has been the custom for lovers to exchange gifts and tokens of their affection on 14 February, St Valentine's Day. Valentine was an obscure priest who was beheaded on that day in the year 270. It is also a day that coincides with the Roman feast of the Lupercalia, held to honour the god Pan, symbol of virility and the coming of spring. By the end of the

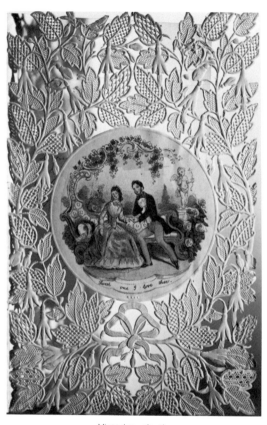

Victorian valentine

eighteenth century hand-decorated letters and poems had taken the place of gifts. They were generally sent anonymously, and the surprised recipient was supposed to guess the identity of the person who 'adored' him or her. In the 1820s Valentine cards could be bought commercially, and were often highly ornate. The printed verse or motto was decorated with lace, feathers, metal hearts, shells, leaves, tinsel, ribbon, or even spun glass. Scented sachets edged with swansdown were also popular. One variety, which originated in France, had a string set in a bunch of flowers on the front, and when the string was pulled the card turned into a miniature paper cage. Valentine envelopes, embossed to look like lace, are now very rare.

One of the best producers of Valentines was H. Dobbs, stationer to Queen Victoria. His cards were renowned for their intricate embossing. The most charming Valentines appeared between 1840 and 1860. Later in the century they declined in popularity, partly because it was more profitable for manufacturers to concentrate on Christmas cards, and also because at the end of the century and up to the First World War Valentines had changed. Vulgar jokes with spiteful and insulting messages had taken the place of tender sentiments and they were sent to enemies rather than to sweethearts. The revival of the sentimental Valentine is largely due to the enterprise of American businessmen.

Wax fruit and glass domes

Glass domes or shades which contained three-dimensional still life in the form of flowers or fruit were an essential feature of Victorian homes and often occupied a place of honour on an already crowded sideboard, occasional table or mantelpiece. There was a dazzling display of wax work at the 1851 Exhibition, and in the

Wax fruit

same year Mrs Peachey's *The Royal Guide to Wax Flower Modelling* was published.

Not many years ago flowers and fruit under glass were rejected by collectors and house decorators, but with the growing nostalgia for the 'security' of the Victorian world they have recently returned to favour with, naturally, a greatly increased monetary value.

Wax flowers usually tend to look a little the worse for wear these days, but fruit can still appear bright and

fresh. Wax flower and fruit making was a Victorian home craft that needed skill in both manufacture and arrangement. They were made by ladies on rainy afternoons and have a charming naivety. The flowers and fruit did not always succeed in looking like the real article, as plastic imitations do today, but that is to their credit and adds to their attractiveness. Domed fruit in fine condition has become quite elusive, though examples with cloth or cut paper work instead of wax are more plentiful.

Wine labels

Wine labels, also known as bottle tickets, are believed to have originated in the early eighteenth century as pieces of parchment or vellum which were tied round the necks of wine bottles and decanters to identify the contents as the glass was almost opaque. When a more permanent and elegant label was needed metal ones, slightly curved to fit the shape of the bottle and suspended on a fine chain, were produced. Because the bottles were prominently displayed in the dining-room the label had to be decorative and made with style to tone in with the surroundings. Two of the earliest manufacturers were Isaac Duke and Sandylands Drinkwater who flourished in the mid-eighteenth century. Every kind of drink, some with long forgotten names, had its own distinctive label. Shrub, sack, arrack, mountain, raspberry brandy and Old Tom were ranged alongside madeira, sherry, whisky and port.

Shapes were varied. There were simple crescents, plain oblongs with chamfered corners, scalloped shells and scrolls, vine leaves, bunches of grapes, and animal forms such as pigs and bulls, though the latter are not often seen. They were made in silver, enamels, porcelain, Sheffield plate, ivory, mother-of-pearl and even pewter.

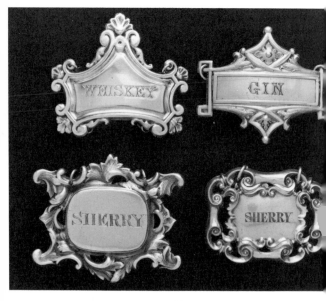

Wine labels

During the nineteenth century labels became more ornate, but the industry declined and finally came to an end after 1860, for in that year a law was passed which made paper labels on wine bottles compulsory.

The collector should also look out for labels for bottles which contained sauces, essences, cordials and perfumes.

SELECT BIBLIOGRAPHY

Armstrong, Nancy: *Victorian Jewelry* (Studio Vista, 1976)

Aslin, Elizabeth: *Nineteenth Century English Furniture* (Faber, 1962); *The Aesthetic Movement: Prelude to Art Nouveau* (Elek, 1969)

Beck, Hilary: *Victorian Engravings* (Victoria and Albert Museum, 1973)

Barnard, Julian: *Victorian Ceramic Tiles* (Studio Vista, 1972)

Bell, Quentin: *Victorian Artists* (Academy Editions, 1975)

Bemrose, Geoffrey: *Nineteenth Century Pottery and Porcelain* (Faber, 1952)

Benedictus, David: *The Antique Collector's Guide* (Macmillan, 1980)

Biddle, G.: *Victorian Stations* (David and Charles, 1973)

Bly, John: *Discovering Victorian and Edwardian Furniture* (Shire Publications, 1973)

Bradford, E. D. S.: *English Victorian Jewellery* (Spring Books, 1968)

Bradley, Ian: *William Morris and His World* (Thames and Hudson, 1978)

Bristow, W. S.: *Victorian China Fairings* (A. and C. Black, 1964)

Coombs, David (ed.): *Antique Collecting For Pleasure* (Ebury Press, 1978)

Coysh, A. W.: *Collecting Bookmarkers* (David and Charles, 1974)

Curl, James Stevens: *Victorian Architecture: Its Practical Aspects* (David and Charles, 1973)

De Voe, Shirley S.: *English Papier Mâché* (Barrie and Jenkins, 1971)

Fearn, Jacqueline: *Domestic Bygones* (Shire Publications, 1977)

Fleming, John and Honour, Hugh: *The Penguin Dictionary of Decorative Arts* (Allen Lane, 1977)

Flick, Pauline: *Discovering Toys and Toy Museums* (Shire Publications, 1977)

Flower, Margaret: *Victorian Jewellery* (Cassell, 1967)

Gaunt, William: *The Restless Century: Painting in Britain 1800–1900* (Phaidon, 1978)

Godden, Geoffrey A.: *Victorian Porcelain* (Herbert Jenkins, 1961)

Harris, Nathaniel: *Victorian Antiques* (Sampson Low, 1975)

Howe, Bea: *Antiques from the Victorian Home* (Batsford, 1973)

Howell, Peter: *Victorian Churches* (Country Life Books, 1968)

Jervis, Simon: *Victorian Furniture* (Ward Lock, 1968)

Lambton, Lucinda: *Vanishing Victoriana* (Elsevier-Phaidon, 1976)

Levey, Santina: *Discovering Embroidery of the 19th Century* (Shire Publications, 1977)

Mackay, James: *An Encyclopedia of Small Antiques* (Ward Lock, 1975); *Collectables* (The Leisure Circle, 1979)

O'Looney, Betty: *Victorian Glass* (Victoria and Albert Museum, 1972)

Osborne, H.: *Oxford Companion to the Decorative Arts* (OUP, 1975)

Payton, Mary and Geoffrey: *The Observer's Book of Pottery and Porcelain* (Frederick Warne, 1973); *The*

Observer's Book of Glass (Frederick Warne, 1976)

Pinto, Edward: *Treen and Other Wooden Bygones* (Bell, 1969)

Randier, Jean: *The Collector's Encyclopedia: Victoriana to Art Deco* (Collins, 1974)

Savage, George: *Dictionary of 19th Century Antiques* (Barrie and Jenkins, 1978)

Spellman, Doreen and Sidney: *Victorian Music Covers* (Evelyn, Adams and Mackay, 1969)

Staff, F. W.: *The Picture Postcard and Its Origins* (Lutterworth, 1966)

Strong, Roy (ed.): *The Collector's Encyclopedia* (Collins, 1974)

Taylor, Nicholas: *Monuments of Commerce* (Country Life Books, 1968)

Toller, Jane: *Treen and Other Turned Woodware for Collectors* (David and Charles, 1975)

Wakefield, Hugh: *Nineteenth Century British Glass* (Faber, 1961)

Wardle, Patricia: *Victorian Silver and Silverplate* (Herbert Jenkins, 1963)

Woodhouse, Charles Platten: *The Victorian Collector's Handbook* (Bell, 1970)

INDEX

Entries in bold type refer to illustrations

188